Limerick's Glory

from Viking settlement to the new millenium

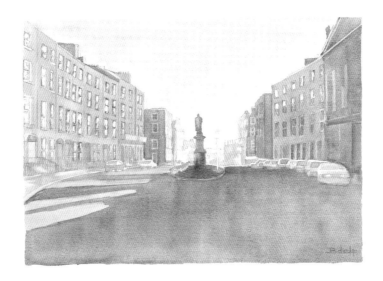

Paintings by Barbara Hartigan
Text by Frank Prendergast and Mainchín Seoighe

Cottage
Publications

First published by Cottage Publications,
an imprint of Laurel Cottage Ltd.
Donaghadee, N. Ireland 2002.
Copyrights Reserved.
© Illustrations by Barbara Hartigan.
© Text by Frank Prendergast and
Mainchín Seoighe 2002.
All rights reserved.
No part of this book may be reproduced or
stored on any media without the express
written permission of the publishers.
Design & origination in N. Ireland.
Printed & bound in Singapore.

ISBN 1 900935 26 0

Frank Prendergast

Frank Prendergast is a native of Limerick and has been active in the City's affairs for over forty years.

A former member of the Governing Body of the School of Celtic studies, Dublin, he is also a member of the Irish Placenames Commission. He has written extensively in Irish and contributes regularly to Radio Na Gaeltachta and TG4 programmes.

A lifelong activist in the trade union / labour movement, he is a retired District Secretary of SIPTU for the Mid West Region, and was awarded a Post Graduate M.A. Degree in Industrial Relations by Keele University, for his research on Multi National Corporations in Ireland. He was Labour T.D. for Limerick East Constituency (1982-87) and a member of Limerick Corporation from 1974-1999. He was Mayor of Limerick in 1977/78 and 1984/85.

He is married to Mary Sydenham and has two boys and two girls.

Barbara Hartigan

Barbara de Lacy Hartigan is a full-time artist living and working from her home in the beautiful rural village of Castleconnell, just seven miles from Limerick City overlooking the River Shannon and the Falls of Doonass. Married to Leslie they have four children Shane, Clare, Erin and Tara.

Painting mainly in watercolours she enjoys all aspects of the surrounding countryside; every season, mood, light and angle provides another challenge.

As an Honorary Member of Limerick Art Society, and founder member of the Market Artists, Barbara has always enjoyed the company of other artists, exchanging ideas techniques and styles.

Her watercolour portraits have become very much in demand and she delights in her collection of diverse and well-known faces her work being exhibited in Ireland as well as abroad.

Mainchín Seoighe

Mainchín Seoighe, a native of the Bruree/ Kilmallock area is author of some thirteen titles dealing mostly with local history, two of which are in Irish and has also been contributing a weekly column to the Limerick Leader since 1944.

He spent his working life as a member of staff of Limerick County Council, and also taught Irish language for many years.

With a keen interest in history, Irish language and culture, people and places , he has also travelled widely, visiting more than 30 countries over the years .

He is a member of the Irish Placenames Commission and is Honourary Curator of the De Valera Museum in Bruree and was Conferred with an Honourary Doctorate by the National University of Ireland in 1990. Mainchín's early writing was published under the English form of his name, Mannix Joyce.

Contents

Limerick City

and its County Border

Rising from the banks of the river Shannon in the north to the high peaks of the Galtee Mountains in the south-east, the county of Limerick is a county of contrasts. From the wide fertile farmland of the Golden Vale in the east, to the wild uplands of Galteemore, to the flat lowlands surrounding the Shannon Estuary, the county presents an ever changing face to visitor and resident alike.

Around the borders of the county lie Limerick's mountain ranges: the Barna Hills to the west, the Mullaghareirk Mountains to the south-west, the Ballyhoura Mountains to the south, the Galtee Mountains to the south-east (their highest peak, and the highest in Co. Limerick, rising to 3018ft), and the Slievefelim Mountains in the north-east.

The land in Co. Limerick is generally of good quality, though unfortunately not all is quite as famous for its fertility as that part of the great limestone plain of Limerick lying to the south and south-east, and known as the 'Golden Vale'. Co. Limerick has for long been recognised as the premier dairying area of Ireland, 'a land flowing with milk and butter', and this traditional industry finds recognition in the official Arms of the county which comprise a green shield with three wavy white bands laid vertically on it, the whole signifying the streams of milk flowing from the fertile green pastures of the county.

The green and white on the shield are most appropriate for another reason: they are also the colours of the Limerick hurling and Gaelic football teams. Superimposed on the shield is a gold cross in a ring, a design taken from the celebrated Ardagh Chalice, a magnificent example of 8th century Irish metalwork, which was discovered in Ardagh, Co. Limerick in 1868, and is now on display in the National Museum in Dublin.

History

Some 165,000 people reside in the county with the major urban conurbation of Limerick City being home for a further 80,000.

It would be impossible to do justice to such a richly diverse area as that encompassed within the bounds of the county of Limerick in a single book. Thus it seemed appropriate to confine ourselves primarily to Limerick City and its environs so as to return to the other delights of the county on another day.

North of the City, of course, lies Co. Clare, so this book deals with Limerick City and that part of the county which surrounds the city on the east, south and west. Roughly speaking, one could say that the book covers an area bounded on the east by the River Mulkear, on the south by the River Camoge and on the west by the River Maigue. The places in the county that you will read about all lie within a 20km (12 mile) radius of the city.

This part of Co. Limerick is, generally speaking, a flat area, resting on a limestone base through which some volcanic material has penetrated in a few places. Because of the flatness of the landscape, any hill, or even slight elevation, within the area adds a pleasant variety to the scene and provides an interesting view over a surprisingly extensive tract of countryside. Very conspicuous is 174m high Tory Hill, the ancient *Cnoc Droim Asail,* 2km north-east of Croom, and a place of considerable archaeological and botanical interest.

The good land of our area and its proximity to Limerick City more than likely were the factors that resulted in the existence of several large holdings or estates in the area. History also played its part in bringing this about, principally the confiscation of Irish lands after the wars of the 17th century, especially the Cromwellian conquest of Ireland in the 1650's and the division and distribution of the lands of the conquered among English Planters. These Planters and their descendants, or those who subsequently purchased their properties, were of a horse-loving breed, and still today the people of the 'Big Houses' – these residences often described as 'gentlemen's places' – ride to the hounds and keep racehorses which they run with marked success in Ireland and England.

In continuance of this heritage in 2001 a new racecourse – The Limerick Racecourse – was opened in the area of our study, near the village of

Patrickswell. It replaces the older Limerick racecourse at Greenpark, on the edge of Limerick City. A few stanzas from an old song about the Limerick Races may not be out of place at this stage:

I'm a simple Irish boy, and wish to see some fun;
To satisfy my mind, to Limerick I did come.
Oh, what a lovely place, and what a
* handsome city,*
Where the boys are all so free and the girls are
* all so pretty.*

There were bookies by the score – "Oh, what will
* win the race, Sir?"*
And one of these sporting chaps came up to me
* and says, "Sir"*
Says he "I'll bet you fifty pounds, I'll put it down
* this minute" –*
"Ah, then, ten to one", says I, "It's the foremost
* horse will win it".*

Incidentally, the large grounds of the Limerick Greenpark Race Course saw huge crowds assemble there on two occasions in recent times: on 29 June 1963, to welcome President John F. Kennedy, and on 1 October 1979, to welcome Pope John Paul II.

Patrickswell, near which the new Limerick Course is situated, is itself a relatively new village that came into existence some time about the middle of the 18th century. It derives its name from an ancient holy well dedicated to St. Patrick that lies within the precincts of the village. Due to its proximity to Limerick City, Patrickswell has grown considerably in recent years. There was an older village called Loughmore about 2.5km north of Patrickswell, but it no longer exists. It boasted a Gaelic poet, Séamus Ó Dálaigh, who used to attend the sessions of *Filí na Máighe*, the Maigue Poets, at Croom, in the mid-18th century. The name Loughmore comes the Irish *Loch Mór*, meaning 'large lake'. It was the kind of lake known in Ireland as a turlough, which describes a low-lying area of limestone that becomes flooded with the coming of the winter rains, due to the welling up of groundwater from the rock. Turloughs vanish during the dry summer weather. The word 'turlough' derives from two Irish words, tur, 'dry' + loch, 'lake'. On occasions when there was a prolonged period of hard frost enthusiastic skaters from Limerick City and the surrounding countryside used to flock there to enjoy themselves on the ice. Some years ago Loughmore was

drained, and that was the end of its temporary winter lake.

A short distance south of Patrickswell, in the townland of Attyflin (*Áit Tí Flainn*, 'the house-site of Flann'), was born in the year 1860, a man to whom Limerick archaeologists and historians owe a tremendous debt of gratitude. He was Thomas Johnson Westropp, an engineer, who developed an all-consuming interest in the remains of the past so plentifully scattered around the country. Because he was a man of independent means he was able to devote all his time to this study. There was scarcely a megalithic monument, or ringfort, or ancient church or castle site in Limerick or Clare (with which his family had strong connections) that he did not visit and describe. Frequently, he made very fine drawings of the places he visited and, in the case of the older remains, he often referred to the ancient legends associated with them. As a field worker he had few, if any, equals. The fruits of his labours were published in several journals, but principally in the *Journal of the Royal Society of Antiquaries of Ireland* and in the *Proceedings of the Royal Irish Academy of Ireland*. Thomas Johnson Westropp died in 1922 but he has left us marvellous descriptions of the remains of

structures, of one kind or another, erected by the Neolithic, Bronze Age and succeeding peoples, in Co. Limerick.

In Westropp's time it was not realised that an earlier people than the Neolithic could have reached the area. However, later research by Professor M. J. O'Kelly, who excavated extensively at Lough Gur, found evidence of a Mesolithic people, and he believed that they could have been there by 4500BC, or a little earlier. Archaeologist Denis Power, who had charge of the Archaeological Survey of Co. Limerick, stated in a lecture he gave at the Joyce Brothers' School, in Kilfinane, on 3 November, 2001, that he had found evidence of a second Mesolithic site in Co. Limerick east of where the Maigue enters the Shannon. These early settlers would have lived by hunting, fishing and food gathering, generally wild fruit, herbs, etc.

Scant though the traces of Mesolithic people may be in Co. Limerick, there is much evidence of Neolithic people there, especially in East Limerick, and, most notably, at Lough Gur which is dealt with later in this book. The Neolithic people were farmers and so were, to a considerable extent,

engaged in food production rather than food gathering. It is almost certain that they were attracted to Lough Gur by its light, well-drained soils, its rich pasturage, its unfailing water supply and its abundant food supplies in the form of fish and game.

Historians differ as to when the Celts came to Ireland. Eoin Mac Neill in *Phases of Irish History* thought that they arrived about 350BC, but T. F. O Rahilly in *Early Irish History and Mythology,* would put their arrival some time before 50BC. In time, Celtic culture and Celtic language (from which Modern Irish derives) came to predominate in the island of Ireland as a whole. The vast majority of the Irish place names of today testify to the predominance of the Celtic language in the past.

Christianity came to Limerick in the 5th century. Popular belief would have it that it was brought there by St. Patrick, but modern scholars believe that Patrick never came as far south as Limerick, and that his mission was almost completely confined to the northern half of Ireland. However there were Christians in the southern part of Ireland before St. Patrick's time

who formed part of the 'Irish believing in Christ' to whom Palladius, St. Patrick's predecessor, was sent by the Pope in 431.

No matter how christianity had actually spread, by the 6th century a number of important monasteries had been established in Co. Limerick including the monastery of Mungret, founded by St. Neasán (Nessan) about four miles south-west of the present city of Limerick, in the early 6th century. It became one of the most important early monasteries in Ireland, and was reputed by the Psalter of Cashel to have had six churches and fifteen hundred monks.

Other important early monasteries in Co. Limerick, but outside the scope of our study, were: Killeedy *(Cill Íde)*, founded by St. Íde, or Ita; Kilmallock *(Cill Mochaellóg)*, founded by St. Mochaellóg; and Ardpatrick *(Ard Pádraig)*, popularly, but erroneously, stated to have been founded by St. Patrick.

One of the early saints most closely associated with Co. Limerick was Mainchín, now generally known by the unsatisfactory anglicized form of his name, Munchin, who is the patron of the diocese

of Limerick; the diocesan college, St. Munchin's College, is called after him. The name Mainchín means 'little monk'.

Gearóid Mac Eoin (ref. 'Original name of the Viking Settlement at Limerick', *Northern Lights*, ed. S. Ó Catháin, pp 168-170) thinks that Mainchín was Abbot of *Tuaim Gréine* (Tuamgraney, Co. Clare), that he was a member of the *Dál gCais* (Dalcassian) family, and that he died in 740. Gearóid refers to an entry from the genealogies of the Dál gCais, which, translated from the Irish, reads:

"It was … Ferdomnach who gave Inis Sibtonn to (Saint) Mainchín of Limerick and to (Saint) Cronan, and Mainchín blessed Ferdomnach with pre-eminence".

Ferdomnach was head of a branch of the Dál gCais who were settled in Clare. Inis Sibtonn, (or Inis Ibdon, to give another version of its name) was the Island on the Shannon on which the Vikings later established the city of Limerick. There may have been an ecclesiastical building on it when Ferdomnach donated it to Mainchín and Crónán. As well as being patron of the diocese of

Limerick, Mainchín was designated patron of the parish of Bruree in Co. Limerick, in 1410, when Bruree church was dedicated to him. Perhaps there was some significance in dedicating Bruree parish to him, as Bruree (*Brú Rí* 'residence of kings') was the seat of the kings of *Uí Fidhgheinte*, an ancient territory that was coterminous with the modern diocese of Limerick.

There is also a holy well dedicated to him in the village of Bruree and in Kerry there is a townland called Kilmaniheen, a name that is a corruption of Cill Mainchín, 'the church of Mainchín'. Here, obviously, there was a church dedicated to him.

Popular folklore, ignoring the chronology of the founding and growth of Limerick, says that when Mainchín was building his first church in Limerick, the workmen were having great difficulty in lifting a particularly heavy block of stone. Mainchín asked a number of the citizens to help, but they refused. Some strangers then came the way, and they gladly assisted the builders to put the stone in position. Mainchín then prayed that strangers would always prosper in Limerick, but that the natives would be unfortunate and

unsuccessful. This was known as *'Mallacht Mhainchín'*, 'The curse of St Munchin'!

Most of the city area and that part of Co. Limerick which form the subject of this book, lay in a territory called *Aos Trí Muighe*. In early times in Ireland, territories often bore the name of the sept or family that occupied them. The name Aos Trí Muighe is an example of this, for it means 'The People of the Three Plains'; the name also emphasizes the flatness of the territory. Roughly speaking, Aos Trí Muighe extended from the Maigue in the west to the Tipperary border on the east, and inland from the Shannon to embrace the northern halves of the baronies of Pubblebrien and Clanwilliam. The Aos Trí Muighe themselves were a branch of the Dál gCais, or Dalcassians. When surnames came into use they adopted the surname Ó Conaing, a name remembered in two of the original Irish placenames in the territory: *Carraig Ó gConaing*, 'the rock of the Ó Conaings', a name now anglicized and corrupted to Carrigogunnel; and *Caisleán Ó gConaing*, 'the castle of the Ó Conaings', now anglicized and mistranslated to Castleconnell.

It was probably the combined attractions of those early wealthy monasteries and the sheltered anchorages of the Shannon eastury that attracted the marauding Vikings, who by 922 had established a settlement on an island in the Shannon, a settlement from which was to grow the City of Limerick. The name of the island has been given variously as *Inis Ibdon*, *Inis Sibtonn* and *Inis Sibhtonn*. In time, however, the Vikings ceased to use the ancient name of their Shannon island settlement, and adopted instead, though in somewhat corrupted form, the old name of the Shannon eastury. This was *Luimnech* (lom + enach, 'bare marsh' – the modern Irish form of the city's name is Luimneach). Professor Mac Eoin speaks of the Vikings borrowing the name Luimnech, and writing it as Hlymrek.

In a note to the present writer, Professor Bo Almquist, of the Department of Irish Folklore, UCD stated:

However, the Vikings wrote the name as Hylmrekr, and it is mentioned twice in Norse Literature: in the thirteenth century Landnámabók (based on twelfth century tracts), and again in the thirteenth century Eyrbyggja Saga, in which there is reference to a traveller

named Hrafn Hlymreksfari, that is 'Raven The Limerick Traveller', or 'Raven the Traveller to Limerick'.

Incidentally, the name Lax Weir for a weir in the Shannon at Limerick is a memorial of the Limerick Vikings, for it comes from the Old Norse Laxaweir, meaning 'Salmon Weir'. Another probable Limerick memorial of the Vikings is the fairly common Limerick surname, Harold. Fr. P. Woulfe, in his *Sloinnte Gaedheal is Gall*, has the following note: *'O hArailt – O Harold, Harold, Harold: 'des Of Harold' (Norse Haraldr): a Limerick surname apparently of Norse origin'.*

Viking Limerick grew to be an opulent, strong and well defended town, protected, it would seem, by a town wall. It was a thorn in the side of the surrounding Irish, especially the Dál gCais, a powerful people on the ascendant in that part of Clare bordering on Limerick. The Dál gCais were descendants of Déisí who had crossed the Shannon northwards from their ancestral homeland in the *Déis Bheag* in East Limerick. In 967, Mahon, the Dál gCais leader – and brother of the yet-to-be-famous Brian Boru, High King of Ireland – inflicted a crushing defeat on the Limerick Vikings

at *Sulchóid* (Solohead) on the Limerick-Tipperary border and afterwards chased the fleeing Vikings back to Limerick, where further great slaughter was inflicted on them and their town set on fire. Viking power in Limerick was broken.

Limerick now became an Irish town and a Dál gCais possession. The descendants of the victorious Dál gCais later assumed the name Ó Briain, or O Brien, after their illustrious ancestor, Brian Boru. In 1088 Muircheartach (Murtaugh) O Brien, King of Munster, transferred his seat from Kincora, near Killaloe, to Limerick. Donal Mór O Brien, who had his palace at Limerick, was King of Thomond (*Tuamhumhan*, 'North Munster') when the Normans invaded Ireland in 1169. Limerick was captured by the Norman, Raymond le Gros, but was retaken by Donal Mór. However, the Normans returned and occupied the city. In the end, a kind of arrangement was made with Donal Mór, whereby he was appointed governor of the city. In this role he kept Limerick independent and free of Norman influence until his death in 1194.

In the following year the Normans finally took possession of the city, and a year later the future

King John granted it its first charter. The Normans greatly strengthened the city's defences, and built King John's Castle, a massive structure, to guard the approaches from Thomond, the North Munster territory of the O Briens. In 1201 King John reserved Limerick to the English Crown, to which it was to remain constantly loyal down to the Reformation, when the religious factor began to put a strain on the relationships.

In the 15th and 16th centuries Limerick was a very wealthy and important city, owing much of its prosperity to the fact that it was a port. In 1574, Limerick born Fr. David Wolfe, a Jesuit priest, who was in Rome as a delegate, 1551-1558, described his native city as *"the strongest and most beautiful of all the cities of Ireland, and encompassed by great walls of living rocks of marble"*.

He went on:-

"The city forms an island in the middle of the rapid Shannon, and can be entered only by two stone bridges, one of fourteen arches and the other of eight. Its distant about sixty miles from the ocean, but ships of four hundred tons can come up as far as the city. The houses, for the most part, are built of square blocks of black marble and like towers and fortresses. The burg of the city is better walled than the city itself, having a wall ten feet thick, and in some places forty feet high, and encircled by ten very beautiful and strong towers to prevent people from approaching the walls. The city has about eight hundred citizens, all of whom are Catholics, except about seven or eight young men ... The city is beautifully situated between Desmond (Deasmhumhan, 'South Munster'), and Thomond, the great river Shannon dividing the one from the other, and were it not for war, has always an abundant supply of corn, meat, milk foods and fresh-water fish" (See J. Begley, *History of the Diocese of Limerick, vol. 11*, pp 158/9*)*

Limerick was to endure three sieges in the 17th century: by the Cromwellians in 1650/1; and by the Williamites in 1690 and again in 1691. The 1691 siege ended with the signing of the Treaty of Limerick, which brought the Jacobite-Williamite War to an end. The terms of the Treaty were considered satisfactory by the Catholic Irish, who had fought for King James and the Jacobite cause, as they guaranteed them civil and religious liberty. With peace declared, thousands of Irish soldiers,

under their leader Patrick Sarsfield, the heroic defender of Limerick, sailed to France to form the famous Irish Brigade in the service of that country. Further thousands of young Irishmen were to follow in their footsteps over the ensuing years. It has been claimed that 150,000 Irishmen died in the service of France alone up to the mid 18th century. Very many others fought for Spain and Austria, and even for distant Russia, where Co. Limerick man, Count Peter de Lacy rose to the rank of Field Marshal. A son of his became a Field Marshal in Austria. In the meantime, however, instead of the religious freedom promised to the Irish Catholics, there was enacted against Catholicism a series of iniquitous laws, commonly called the Penal Laws.

In 1760 it was declared that Limerick City would no longer be a fortified city, and shortly afterwards began the demolition of its centuries-old walls and gates, breached and battered so many times by attacking forces. In this regard, one will surely agree on the appropriateness of Limerick's motto: *Urbs antiqua fuit studiisque asperrima belli*, 'It was an ancient city hardened in the pursuits of war'. Shortly after the demolition of its confining walls, Limerick began to spread westward along the banks of the Shannon as Newtown Pery began to take shape. Newtown Pery is a superb example of 18th century town planning. It is laid out in wide parallel streets and regular blocks of mainly red brick houses – lovely Georgian buildings that lend grace and elegance to this part of the city. O Connell Street, Limerick's principal thorough-fare, is in Newtown Pery. However, the name Newtown Pery is now seldom, if ever, used. Modern Limerick is a vibrant thriving city that looks to the future with the greatest confidence.

The writer, Kate O Brien, a native of Limerick, makes a very nice comment about the Shannon and Limerick, in her book, *My Ireland*. She says:

The Shannon is a formidable river; nothing parochial about it, nothing of prattle or girlish dream. It sweeps in and out of the ocean and the world according to the rules of far-out-tides, and in association with dangerous distances. So its harbour has been long accustomed to news and trouble in and out, and in the general movement of time Limerick has been shaped as much by invasions and sieges as by acts of God and the usual weathering. It is for Ireland therefore a representative city: whatever happened in Ireland

happened also here – and some things happened to Ireland because of things that happened here.

Perhaps the most important development in the area of our study was the establishment of the University of Limerick. The University began as the Limerick Institute of Higher Education in 1972. Other important developments in the contiguous area included the provision, on the Cork-Limerick road, of a multi-million by-pass at Croom, which was opened in the summer of 2001, and the provision of 31km of major roadway stretching from the Lantern Lodge, near Adare, to Annacotty, on the Limerick-Dublin road. This mammoth undertaking, when completed, will have cost more than £150 million, (190 million Euro) and will have provided an invaluable transport artery through the middle of Co. Limerick, easing traffic flow throughout the city and the country.

Many people from the outlying area commute to Limerick City to their work. However, the industrial estate at Raheen, close to the city, provides employment for many of the local population. In the nearby little village of Mungret there is a thriving cement factory, built in the

1930s, at a time when the government of the day, newly-elected, set about making the old nationalist dream of self-sufficiency a reality.

Even in the area we have chosen to explore it is impossible to cover everything in the detail one would like. Apart from the villages specially featured in later sections, there are many others that merit some mention – Annacotty, Fedamore and Clarina to mention but three.

Annacotty (*Áth an Choite,* 'the ford of the small boat'), once had a paper mill. It is pleasantly situated near where the River Mulkear flows into the Shannon and at this point I might introduce an old song about the Mulkear:

Tis well I do remember too how in my youth
* and bloom,*
I hunted on that mountainside by Cappamore
* and Doon;*
By Carrickbeg and Castletown, places you all
* well know,*
And Gurtavalla's marshy banks where the
* Mulkear's waters flow.*

Fedamore once had a Franciscan friary situated

near it, in the townland now called Friarstown, but formerly known by the Irish version of that name, *Baile na mBrathar*. Fedamore has continued to be a stronghold of the native game of hurling, and has produced several hurlers who won all Ireland medals, playing with the Limerick county team. Hurling is a favourite game in Limerick, and its very many aficionados have no doubt that it is the world's greatest field game, being incredibly fast and calling for great skill, quick thinking and courage. Other places in the section of the county we are dealing with, where there is a very strong hurling tradition, include, apart from Fedamore, Ahane (in Castleconnell parish), Croom, Patrickswell and Ballybrown.

Clarina is a small village about 8km south-west of Limerick, and about 1.5km equidistant from Mungret and Carrigogunnel. A short distance north of Clarina, stood Tervoe House, up to its demolition in 1953, home of the Monsell family. William Monsell (1812-1894), First Baron Emly of Tervoe, was an interesting personality. Close to Tervoe House, he and his wife, Berthe de Montiguy, of a very aristocratic French family, erected the very first Lourdes grotto in Ireland.

Matthew Potter *(Ballybrown Parish Journal, Christmas 2001, p 19)* says of him:

"He had sat as MP for Co. Limerick from 1847 to 1874, and in the latter year was raised to the peerage as Lord Emly. He had become a Roman Catholic in 1850, and was one of the leading lay Catholics in the (then) United Kingdom. He held office in a number of Liberal administrations in the 1850s, 1860s and 1870s. In 1871, he had been appointed Lord Lieutenant and Custos Rotulorum of the City and County of Limerick, and as such had been the leading civil and military figure in Limerick for twenty-three years. He had been Colonel of the County Limerick Militia since 1864 and vice-chancellor of the Royal University of Ireland since 1855. He was the friend of Prime Ministers, Peers, Cardinals and even Popes. As he lay on his deathbed in Tervoe House, the Bishop of Limerick, Dr O'Dwyer visited him daily, and shortly before his death, Pope Leo XIII telegraphed his blessing from Rome to the distinguished and venerable old gentleman. Thus when Lord Emly breathed his last on 20 April, 1894, it was an event of national importance".

Writing is another activity that has been cultivated with some success in our area. There were the 18th century Gaelic poets, Aindrias Mac Craith and Seán Ó Tuama, who were closely associated with Croom. There was the poet, novelist and dramatist, Gerald Griffin (1803-1840); poet John Francis O Donnell (1837-1874); poet and song writer, Michael Hogan, 'The Bard of Thomond' (1832-1899); novelist, Kate O Brien; Críostóir Ó Floinn, a most prolific writer, in Irish and English, in practically all genres of literature; poet Desmond O Grady; novelist Michael Curtin; essayist and poet Séamus Ó Cinnéide; and the latest addition to the roll of Limerick writers, Frank McCourt.

There is much more to read in the following pages about Limerick City, and about that part of the country that surrounds it and which forms the subject of our book. We hope you will enjoy it.

Mainchín Seoighe

Of all the institutions and communities that have contributed to Limerick's rich heritage over the centuries, there can be very few with a more fascinating history than that of the Abbey Fishermen. The Abbey in question was located in the Englishtown about half way between Abbey Bridge and Bishop O'Dwyer Bridge.

The main fishing families, who lived in its precincts for centuries – Clancys, MacNamaras, Hayeses and Shannys – were members of what is believed to have been Limerick's oldest guild, the Guild of Abbey Fishermen. The boats they used were called 'brocauns', three men to each boat, which operated in pairs with a snap net drawn between them. They have used this method for centuries; an old map of the city dated c. 1590 shows a number of these fishing cots.

The system they used to allocate fishing areas to each boat is believed to date from the Brehon Laws. The members met at the city courthouse each spring and used a lottery system to decide which boat got what was called an 'innure' a word deriving most likely from the Irish for harbour 'inbhear'. Their greatest legacy for place names specialists and historians was their ancient list of place names for every field, harbour, falls or weir on the Shannon, from Barrington's Pier to Doonass. These names are so old that in several cases they have defied translation by experts and scholars from *An Coimisiún Logainmneacha,* the Placenames Commission.

Given the established antiquity of all the town land placenames in the city and its suburbs, it is not at all an exaggeration to suggest that some of the names handed down for generations by the Abbey Fishermen could well be a thousand years old.

Their centuries old fishing rights were ended however, when the ESB (Electricity Supply Board) in 1929 began to operate Ireland's first hydroelectric scheme at Ardnacrusha near the city. The head race or canal needed for this meant that millions of gallons of water were diverted into it from the main river thereby reducing its level and force. The salmon were attracted into the canal, with disastrous consequences for the fishermen. Their inevitable defensive battle with the ESB authorities finished in the city courthouse in January 1933. The Abbey Fishermen refused to pay the fines imposed and these were eventually quashed.

The Shannon Fisheries Act of 1934 terminated the issue of snap net licenses and a long battle for compensation ensued which involved the Hayes, Clancy, MacNamara and Shanny family. The compensation list itself, with the nicknames, names, ages, addresses and amounts paid to each member is a valuable research source for the local historian.

The Abbey Fishermen
THE ABBEY RIVER AND BRIDGE

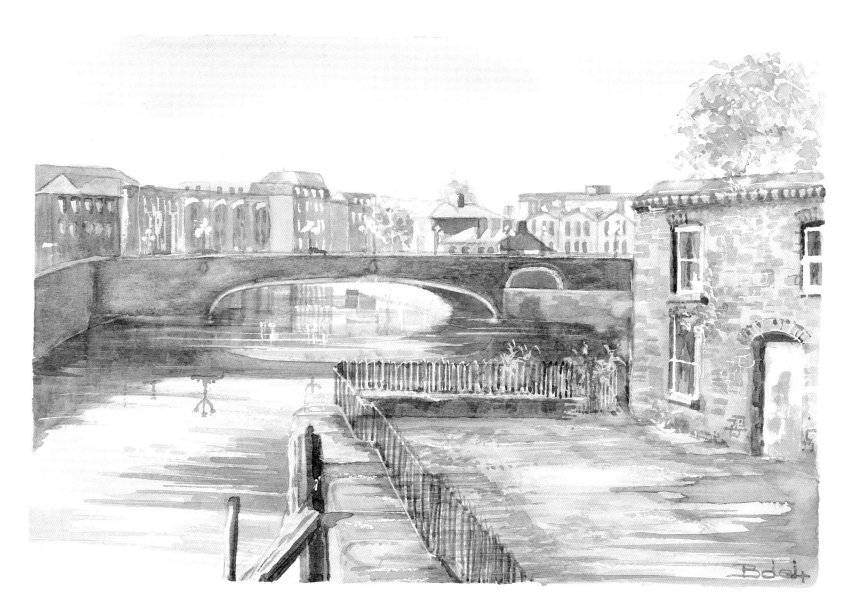

Limerick has been a major port for over five hundred years, exporting and importing goods to and from all the major trading countries in every continent of the world. Local businesses such as the Arthurs, Horans, Spaights, Russells, Mullocks etc, were to become very successful following the opening of the new docks in the 1750's. Emigration to America and Canada was common in the 1830's, well before the Great Famine (1845-1848) and was a regular source of income for the shipping merchants.

The horrors and deprivation involved for the passengers have been well documented, but one of the saddest incidents to endure in the local folk memory related to the fate of a young cabin boy, fifteen year old Pat O'Brien of Thomondgate. Having worked for a time on the docks, he embarked as a crew member in 1835, on a voyage of the 'Francis Spaight' named after her owner, when she sailed for St. John's, New Brunswick, Newfoundland, with a complement of 220 souls, and a crew of eighteen.

On her return voyage with a cargo of timber, she ran into a snowstorm and strong gales, which washed their provisions overboard. Equally badly, their drinking water supply became fouled; a dangerous situation in the days of sail, when a ship often became becalmed. Three of the crew were lost in the storm. The timber cargo kept her afloat until the eleven surviving crew members were rescued by the US Brigantine 'Agenoia' on the 23rd December, having suffered pain, hunger and hardship for twenty days.

Five days before their rescue, the crew realised that the only way they could survive was by eating human flesh. Lots were drawn and young O'Brien drew the short straw. He was killed and disposed of with a penknife as a result of which two of his colleagues went mad and suffered the same fate. The gruesome details in the 'Limerick Star' newspaper of June 1836 were cited in the Times of London on the 22nd of that month. The crew were put ashore in Falmouth England and after an inquiry by the authorities there, they were judicially acquitted. On their return to Limerick, a public subscription was raised, to which the ship's owner, Francis Spaight, made a contribution of £10.

There was a strong tradition in the folk memory well into the mid-20th century that the boy's mother, Mrs O'Brien, used to go on her knees on the street, open out her hair and curse Captain O'Gorman on his way to Mass.

Captain Kevin Donnelly of the Limerick Harbour Commissioners recalled being told by an old Limerick seaman that a shipmate in Liverpool had asked him once, *"are you one of the crew who ate the galley boy?"*

Lament For Pat O'Brien
THE DOCK CLOCK

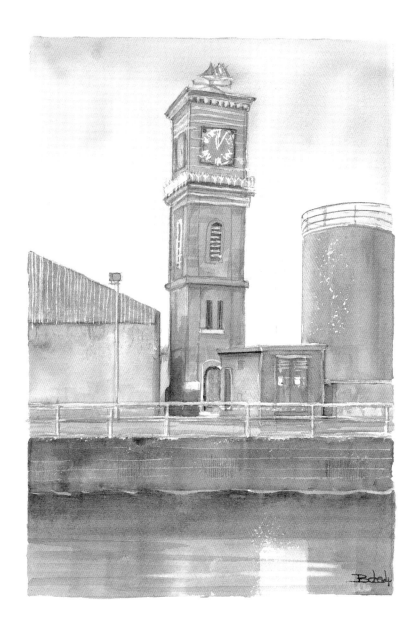

The Newtown Pery area of Limerick has often been described as "one of the best preserved Georgian precincts in Britain or Ireland". Its magnificent red brick symmetry is an architectural delight, which has been the subject of very favourable comment by all the significant visitors here, since its foundation in the mid-18th century.

The main thrust for the development of this new town as distinct from two older parts of Limerick, the thousand year old viking city – the Englishtown and the Irishtown – came as a result of the disaffection of the city's more progressive businessmen who were disgusted at the political corruption and gross mismanagement of the city's affairs by Limerick Corporation. These businessmen were led by the thirty one year old Edmund Sexton Pery.

They set about developing their new town in the Georgian architectural style on the marshy area known as South Prior's land between the present day O'Connell Street and the Parnell Street / Boherbuoy area. According to the distinguished Limerick born author Louie Byrne, who is an authority on the subject, the area involved had been built upon earlier houses, the sewerage systems and underground cellars of which can still be seen to the present day.

The building of the new town began in 1750 and took the form of a square grid of streets and footpaths, which were cleaned and maintained by the Commissioners who also provided the most modern public lighting system available. Their new Town Hall is now the Head Office of the Limerick City VEC and the enclosed Athenaeum Theatre, later the Royal Cinema, now closed. This was used for public debates and lectures. The main feature of the New Town was George's Street (O'Connell Street), of which the great English writer W.M. Thackeray wrote on this visit here in 1842,

"the great street of Limerick is altogether a very brilliant and animated sight".

Another very pleasing feature of the area was its beautiful People's Park, dominated by the magnificent pillar memorial to Thomas Spring Rice MP, who was married into the Sexton family. He was born at No. 2, Mungret Street, and became Chancellor of the Exchequer (1835-1839). The adjoining Pery Square is a truly exquisite model of Georgian architecture as is the nearby Crescent in O'Connell Street.

The whole Georgian precinct of Limerick is protected by a Preservation Order of the Limerick Corporation.

Georgian Limerick
St. Michael's Church, Pery Square

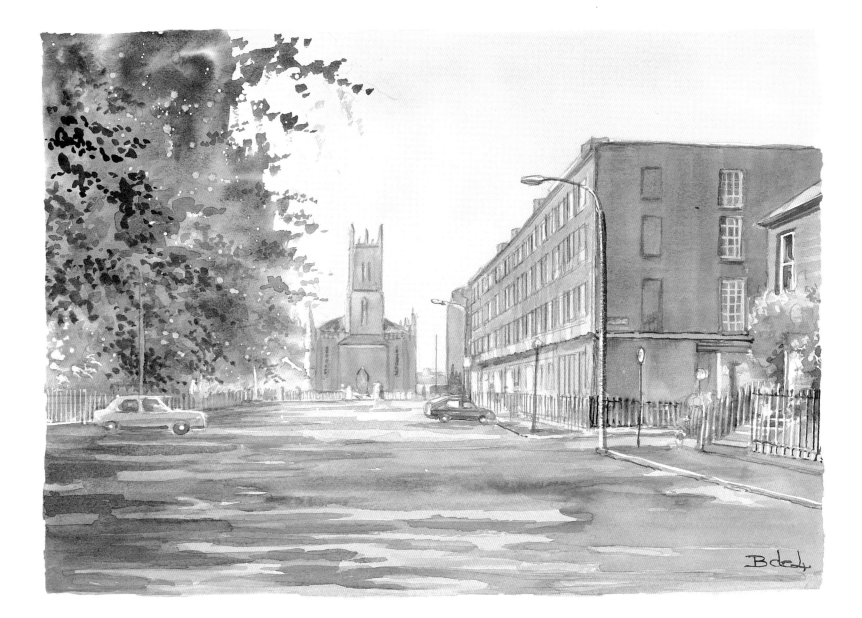

The claim that Limerick is the sports capital of Ireland is likely on balance to stand up to any rigorous scrutiny. In terms of population and distinctions earned, few other counties can equal its record.

Although hurling fortunes have suffered somewhat in recent years, the county has won the All Ireland title on six occasions and the recent All Ireland victories of the U21 sides in hurling and football suggest that a recovery is beginning.

Limerick's ladies too have made history with All Ireland Club Championships in football by Gerald Griffins and twice winners Granagh / Ballingarry in camogie. Limerick's place in Ireland's sporting pantheon is secure forever, however, as it produced the non-pareil of hurling, the immortal Mick Mackey of Ahane. Many hurling commentators regarded him as the greatest hurler of them all.

The county's record in athletics too is immense, having produced three Olympic champions in the early 1900's. John Flanagan of Kilbreedy, Kilmallock won ten world records in weight throwing and was three times gold medallist at the Olympic Games in Paris, 1900, St. Louis 1904 and London 1908. Paddy Ryan of Pallasgreen won the gold medal for hammer throwing at the Antwerp Olympic Games in 1920. Con Leahy of Cregane won the gold medal for the high jump at the Olympic Games in Athens in 1906.

He left shortly afterwards for America and on the day he arrived there, won the World High Jump title at the Jamestown Exhibition. One of seven brothers, four of them – Paddy, Con, Joe and Tim – were remarkable athletes and won thirty-three Irish titles between them.

J.J. Brosnihan of Castletown broke the world record three times, in the hop, step and jump on the 26th August 1906, but was disallowed on technical grounds. In later times, the county produced another crop of international and Irish champion athletes in every decade of the 20th Century, such as John O'Grady, Stan De Lacy, John O'Donnell, Pat Hartigan, Neil Cusack and Frank O'Meara etc,

While the county never produced a George Best or Roy Keane, it can be argued nevertheless that a very respectable Irish soccer team could be selected from Limerick-born players.

In hockey, the great LPYMA nursery produced amongst others, Bill Stockil who won the first of fifteen Irish caps in 1924. His clubmate, the legendary Stan de Lacy, captained the British and Irish team on their South Africa and Rhodesia tour of 1950, a tour which included another Limerick player, Noel O'Dwyer of Lansdowne Hockey Club.

Sporting Limerick
THE RUCKER AND THE PUCKER STATUE

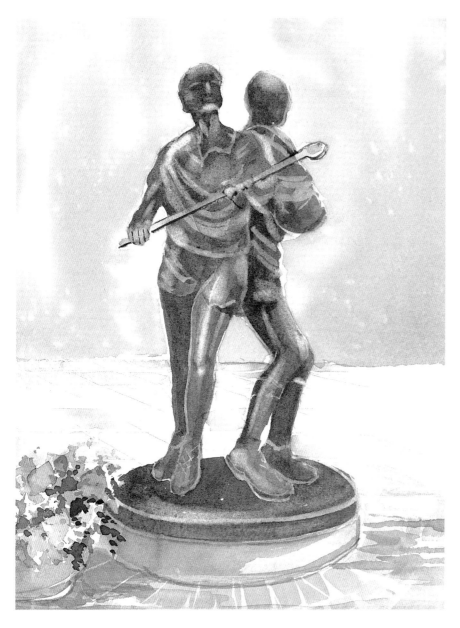

Noel's father was the celebrated Major Ged O'Dwyer of the world famous Irish Army Equestrian Team of the 1920s & 1930s era. On his famous horse, 'Limerick Lace', he was a member of the team which won six Aga Khan Trophies. He won forty-six show jumping championships including sixteen Nations Cups.

But Limerick and horse racing have long been synonymous, from the Moloney brothers of Croom, Martin and Tim in the 1940's / 50's era to Michael Hourigan and Doran's Pride at present. Martin Moloney was Ireland's champion jockey from 1946-1951, winning three Irish Grand Nationals, three Classics, and the Gold Cup at Cheltenham in 1950. Tim was champion jockey of England, for five years, winning the unprecedented feat of four Champion Hurdles and every national race there except the Grand National. Liam Ward of Rathkeale was winner of twelve Irish Classics and the French St. Ledger. Enda Bolger of Howardstown won the Foxhunters' Chase at Cheltenham in 1996.

Limerick's place in sport has been further enhanced with the victory of Sam Lynch of St. Michael's Rowing Club, in the World Lightweight Sculling Championship in Lucerne in 2001.

The decision of the Government to locate the magnificent National Coaching and Training Centre on the Campus at the University of Limerick at Castletroy can only be a happy augury for Limerick's dominance in Irish sport, into the next century and millennium.

In Limerick as elsewhere, markets and fairs were essential parts of urban and rural society where the people met to do business and exchange the latest news and gossip. The earliest reference to a fair in the county is that of Knockainey, contained in the Annals of the Four Masters, which date back to the 7th century BC, which was then an important place in pre-Christian Ireland.

Maurice Lenihan in his History of Limerick, recounts also that *"the want of a market having been thus early experienced by the busy and energetic (Norman) settlers, King Henry III in the first year of his reign (1217), conceded to Edmund, Bishop of Limerick, a weekly market every Tuesday at his Manor of Mungret"*. People who lived in the Liberties outside the city did not have to pay tolls when they came to market to sell their wares. Under the Feudal laws then in operation, people who lived outside the Liberties however, had to pay tolls on their produce as they entered the city's dominion. The most recently used toll houses were at Athlunkard Bridge; that for the South at the left hand side of Ballinacurra, on the city side of the Creek river (the small house on this spot was demolished about ten years ago); that for the West was located at the Avondonn river (Two Mile Forge) on the Cratloe Road and that for the Eastern entrance was on the city side of the Groody River at the bottom of the hill where it can still be seen occupied by its traditional owners – the Tobin family.

Although most of the mediaeval markets must have been in the oldest part of the city – the Englishtown – the only ones we now associate with that area are the Potato Market on the site of the former Viking harbour and those long vanished at Meat Market Lane and Sheep Street.

All the other markets for hay, corn, milk, cabbage, etc, were located for centuries in the Irishtown, but the principal marketplaces were at Mulgrave Street. The markets were held on Wednesday and Saturday. Fairs traditionally were held on Tuesday of Easter Week, July 4th, August 4th and December 12th, at the Fairgreen at the Pike. The Great Munster Fairs were held on the last Thursday and Friday in April and October. An ancient privilege attached to the August Fair, namely that nobody could be arrested for fifteen days for issues normally dealt with by the Tholsel Court.

The recent innovation by the Market Trustees and Limerick Corporation with the lovely restoration of the old Market House has put it on a par with any other market in similar sized cities throughout Europe. The 'buzz' and excited banter and chatter there every Saturday make it the most exciting meeting place in the city.

Limerick's Fairs and Markets
THE MILK MARKET

Amongst its many other causes for occasions of civic pride, Limerick is particularly fortunate to house one of the great private art collections of Europe, the Hunt Collection. It is situated, fittingly, in the city's old Custom House, described by Desmond Fitzgerald, the Knight of Glin and a noted art connoisseur, as *"Limerick's most distinguished example of 18th century architecture"*.

The collection itself has more than three thousand artefacts ranging from the Neolithic and Bronze Ages to mediaeval sculptures in addition to works by Leonardo Da Vinci, Picasso, Renoir, Gauguin and Henry Moore. These priceless items were collected over a lifetime of fifty years by two internationally renowned art experts, John and Gertrude Hunt, who settled in Ireland in 1939 at the outbreak of the Second World War. They made their home at Lough Gur in County Limerick, an area steeped in pre-history and archaeology.

They had met each other in the 1930's when they had been working as acknowledged specialists in the area of mediaeval fine arts. This was a very good period for anybody interested in the collection of antiques because the major European museums were spending their scarce resources in rebuilding after the 1914-18 war and the American collectors did not show any great interest. The Hunts were involved in restoring some of the great European collections of fine art and helped to establish others notably, for example, for the Aga Khan, Sir William Burrell in Glasgow, and the great Hearst Collection in San Simeon in California.

They spent some years also as consultants to Sotheby's of London. They always wanted however, to establish their own collection. Gertrude in particular, was able to rescue very valuable artefacts from some of the collections which were being dismantled and whose values were not fully appreciated by other collectors. She had been born in Mannheim in Germany in 1903 and she acquired her expertise in her youth in the various German castles when her father had worked as a master of the hunt.

With her husband John, she established what has been recognised as one of the world's greatest private fine arts collections, which they gave to the Irish nation in 1976, when it was housed in the University of Limerick through the good offices of its President, Dr. Edward Walsh. Their children John Junior and Trudy arranged to have it located in its new permanent home in the magnificently restored Old Custom House where it is seen by thousands of visitors annually. This location has been hugely enhanced by the recent construction of a beautiful marina on its doorstep, so to speak, making it one of the city's loveliest and busiest tourist attractions.

The Hunt Museum
THE HUNT MUSEUM

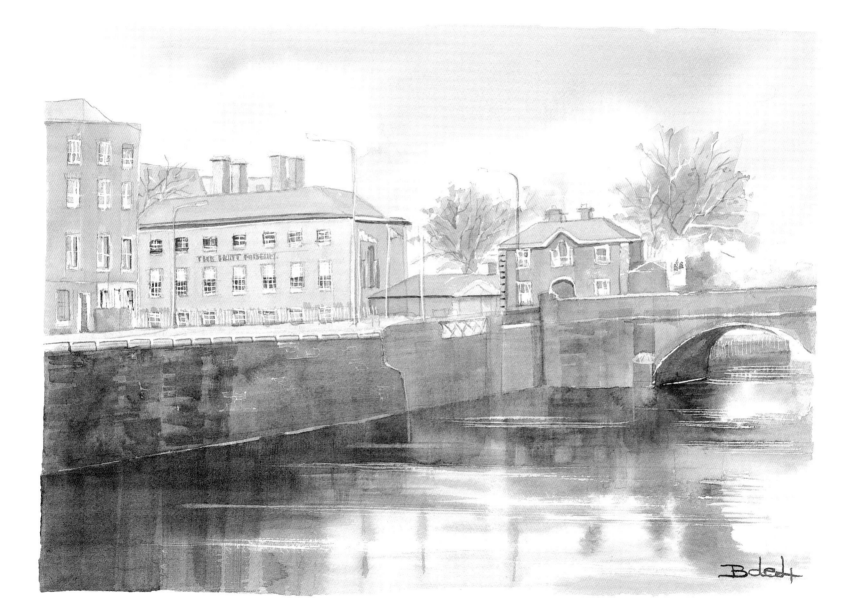

Above all other sports, Limerick is the home of Irish rugby and Thomond Park its Mecca, a fact long known by visiting teams. It has been synonymous with the game for well over a century. Its seven senior clubs Garryowen, Shannon, Young Munsters, Old Crescent, UL Bohemians, Thomond and Richmond, and its junior clubs St. Mary's and Presentation are institutions in their own right, with passionate supporters and local loyalties. Garryowen FC, its oldest senior club, has given its name to the game's international vocabulary, the 'Garryowen' called after their traditional attacking ploy, the 'up and under'. The club has, since its foundation in 1884, produced fifty-two internationals, eight British and Irish Lions, several Irish team captains, the 1978 European Player of the Year, Tony Ward, and current Irish captain Keith Wood, who in2001 was voted the World International Player of the Year.

Garryowen have had two Presidents of the IRFU in D. G. O'Donovan and Kevin Quilligan, whose son John will be President in 2003/4, as well as Irish team manager Pat Whelan, assistant coach Phil Danaher and current coach Eddie O'Sullivan.

Shannon, the City's foremost rugby nursery, has been the dominant senior club in the 1990's, winning the All Ireland League four years in a row; a feat not likely ever to be repeated. Since its entry into senior rugby in 1954, Shannon have won 13 Munster Senior Cups and they have been a major source of great players to the currently successful Munster and Irish teams, including the Munster Captain Mick Galwey and his colleague Anthony Foley (who recently captained Ireland against Samoa), as well as current Irish team manager Brian O'Brien, himself a former international. They have also produced three British and Irish Lions in Mick Galwey, Colm Tucker and Gerry McLoughlin.

Young Munsters too have made their name in rugby as far back as 1928, when they won the Bateman Cup, and when they became All Ireland League champions in 1992/3. Amongst their internationals, they have produced two of Ireland's all time great forwards, Tom Clifford and Peter Clohessy, who were selected as British and Irish Lions and were immensely popular figures.

UL Bohemians too have had a distinguished past and produced several great internationals such as Mick English, Bill Mulcahy, Sean MacHale, and Brian Spillane.

While now a senior club, Thomond have undoubtedly been the most successful at junior level, winning the Munster Junior Cup on no fewer than 7 occasions between 1971-1991. With six schools now playing rugby, the game's future association with Limerick is secure.

Munster Rugby
THOMOND PARK

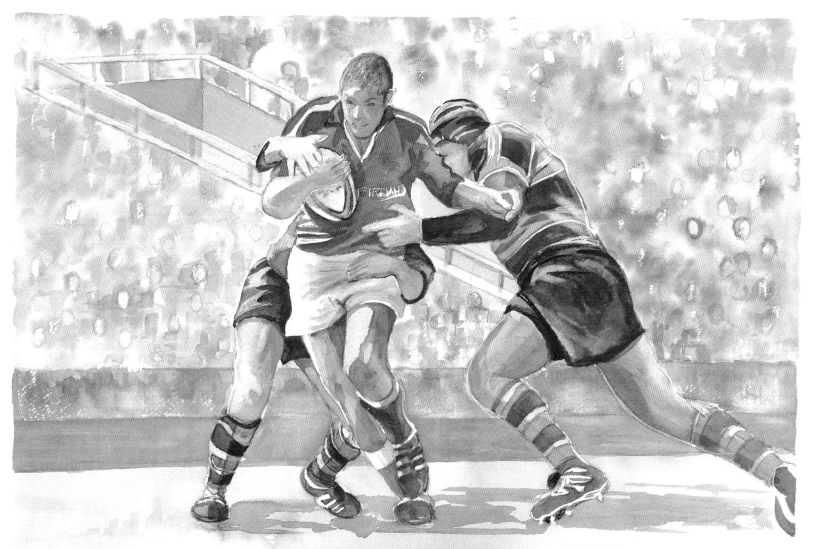

One of the most fascinating clues to the richness and diversity of a town's or city's history can be found in a study of its streetnames, and Limerick is particularly well-off in this regard, because it was a walled town. Prior to the development of the 18th century Georgian area of Newtown Pery, the older city consisted of two separate towns in the shape of an hourglass, the mediaeval Englishtown, and the 14th century Irishtown, names that have survived to the present day.

Tradition tells us that the oldest known street name extant in the City is that of Fish Lane running eastwards from the old Main Street – now Nicholas Street – to the Abbey River. Many of the names surviving in that area give us a clear idea of the industrial, political and religious influences commemorated in its streets and lanes. Glueyard Lane, St. Francis Tannery, The Sandmall, Sheep Street, Meatmarket Lane, Castle Street, Exchange Street, are all a testimony to their historic origins. The Viking heritage is reflected also in the name Athlunkard Street which in its Irish form, – *Áth an Long Phoirt*, the ford of the camp or fortress, dates from the Viking era and their practice of protecting their ships with such fortifications.

The recent discovery of a Viking Harbour on the Parteen side of the Shannon facing St. Thomas' Island at Athlunkard should be ample proof of its etymology.

The Irishtown too, to the south of the Abbey River, has its share of old street names as we see from the Civil Survey (1654). This includes the name of Curra Street, now sadly almost defunct, which runs parallel to Broad Street, from Grattan Street to the Abbey River at Merriman Place in Old Clare Street. The four main streets of the Irishtown were Broad Street, John Street, High Street and Mungret Street, which was formerly called Pilgrims' Road as it led to the ancient important monastic settlement there.

It is vital to our sense of pride and place that our streets should retain and reflect the influences that affect the lives of its citizens. Over a hundred names of our old streets and lanes have already been changed and in some cases forgotten. The European Urban Charter cautions us that *"a town without its past is like a man without a memory"*. How true!

It this regard, the present Government policy that all new housing estates names must reflect the area's history, heritage and traditions, is opportune and greatly to be welcomed.

Limerick's Eloquent Street Names

ATHLUNKARD STREET

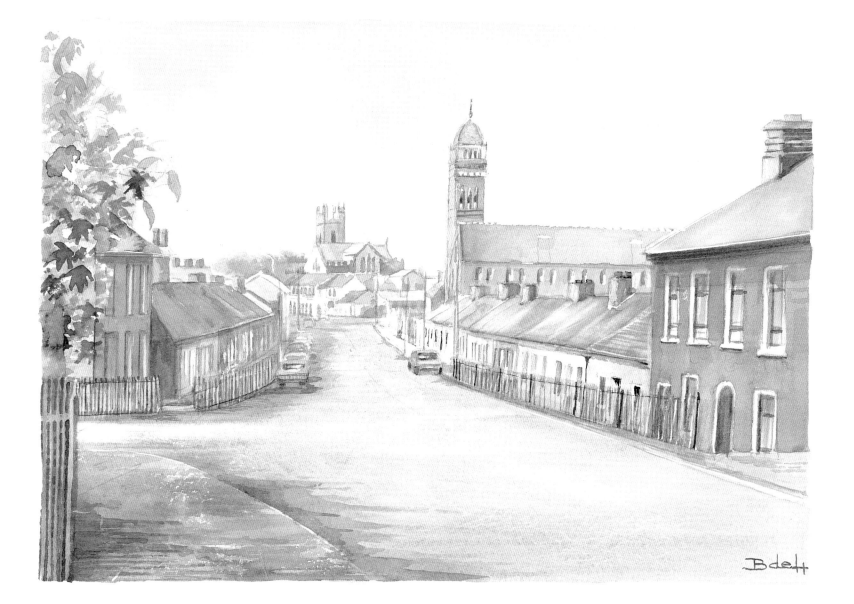

Even though it was largely absorbed into the City in 1844, St. Patrick's parish has retained its rural character to this day, despite all the modern housing developments of recent years. The families, many of whom have lived there for centuries, glory in the title 'Patrick's People', because of the very many strong traditions which have survived there associating the area with our Patron Saint and his visit there during his travels throughout Ireland.

Robert Herbert, the late Limerick City Librarian, has written, convincingly, of the long-standing belief of the Park people that they were descended from Limerick's Vikings; they are described colloquially by the rest of the citizens as 'the Park Danes'.

They were a distinctive close knit community easily recognised by their rural style of dress and generally held in very high esteem by the rest of the City people. They worked very hard in their vegetable plots *'ó dhubh go dubh'* – from dark to dark – starting often in summertime at three o'clock in the mornings. They never changed their clocks to summer and wintertime like the rest of the City, but kept 'God's Time', as was the custom in rural Ireland generally up to the 1950's.

The late Kevin Hannon, seanchaí and local historian par excellence, in his fascinating book *Limerick; Historical Reflections*, recalls that matchmaking was a feature of life in Park until well into the 20th century. He describes vividly the modus operandi of the last matchmaker there, Jimmy Clancy

of Rhebogue, "*who knew every Park family between the Groody River and the City bounds, and between the western bounds of Singland and the Shannon.*" He tells us that "*he had to deal exclusively with an ancient, self centred and self contained community whose demands were as peculiar as their unchanging way of life*".

Another custom which survived well into the 20th century was that of each family paying a half penny a week to a man whose duty it was to call each of the gardeners to work by tapping on their doors or windows. One family, who lived near the market cross there, recalled with unconscious pride that they were the first Park family to own an alarm clock.

They were, generally speaking, of a quiet, gentle conservative disposition and diligent in attendance at all their church ceremonies. At Mass, the congregation divided – the men on one side and the women on the other.

These quaint endearing customs are sadly no longer part of the Park way of life today, but the people there are still held in the same esteem by the rest of the City, as were their people for generations.

Park's Viking Colony
THE BRIDGE AT PLASSEY

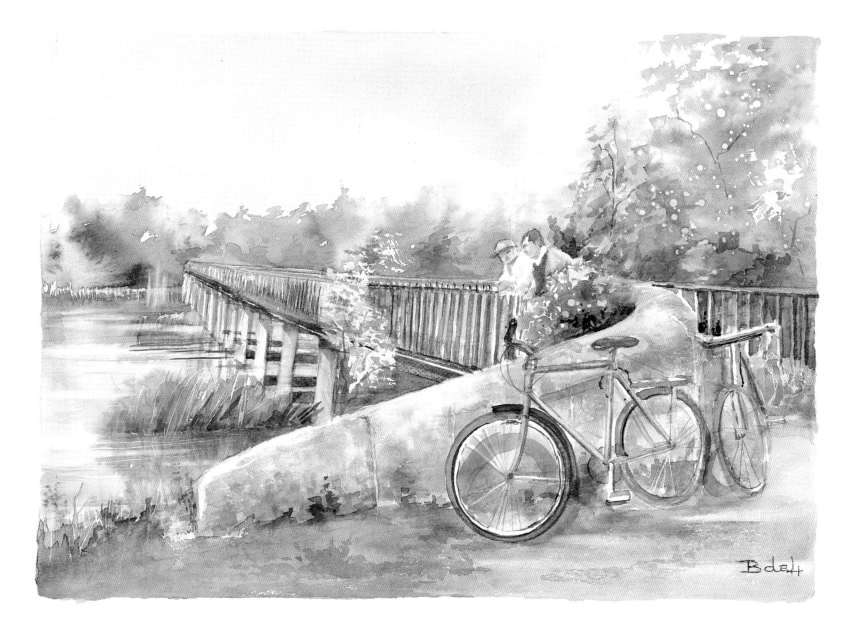

The decision of the City Corporation to have Baker Place – where according to local tradition, potatoes were first grown in Limerick on the site of the National Hotel – re-designated as a city square, has been warmly welcomed by the public, as it will complement the elegant 18th century Pery Square to its west.

This project is designed to rejuvenate Limerick City centre by having a paved square around Tait's Clock, introducing trees and street furniture and directing the present heavy traffic volume away from Taits Clock. This should enhance the gracious Georgian precinct of the People's Park and Pery Square, named after its architects, the Sexton Perys.

There can be very few more beautiful urban developments in Ireland than the Pery Square Tontine Buildings, number two of which has been so successfully restored by the Limerick Civic Trust as a Georgian House showpiece. Directly opposite is the City's major park, the People's Park which was opened on 26 October 1874. Although built by the Richard Russell Memorial Committee to honour one of the City's best known businessmen and benefactors, Richard Russell of Plassey, it has always been called by the public 'the People's Park'.

Before it was developed as a park, the area had been very unsightly waste ground, which must have seemed an eyesore and embarrassment to the patrician residents in the Tontine Houses across the road. The prominent businessman, James Spaight, at a City Corporation meeting in June 1874 denounced it as *"a blot on the appearance of the City, an eyesore, a disgrace and a danger because of its unsanitary condition"*. The Corporation agreed that a park would be developed at Pery Square to honour Richard Russell, and the site was granted by a member of the Sexton Pery family, the Earl of Limerick (a close friend of Russell's) on a 500-year lease.

The lease stipulated also, however, that Reeves' Path, now Upper Mallow St., which was then only a boreen, would be upgraded to a proper street and that the Corporation would within three months designate the Pery Square lands a People's Park and spend £150 each year on its maintenance and improvement.

To this day, the Corporation to its credit, has more than honoured those stipulations; it is as beautiful a public park as can be seen anywhere and is a source of great pride and pleasure to the people of Limerick.

Pery Square and the People's Park

PEOPLE'S PARK

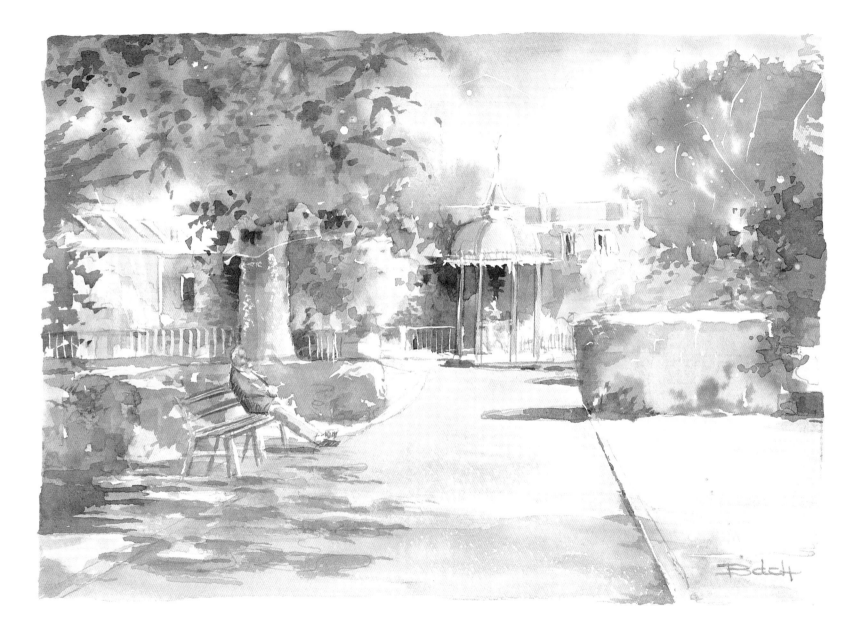

Probably the most enduring feature of the active Norse presence in Limerick which lasted for over four hundred years from the 10th to the 14th century is the widespread survival of their family names in Limerick and the mid-west region of Ireland generally. Apart from the broad designations by the Irish of the Norwegians as fair-haired foreigners, Fionn Gaill (Fennell), and of the Danes as black-haired, Dubh Gaill (Doyle), the present day telephone directory is replete with such Viking names as Broderick, Setright, Mac Auliffe, Costelloe, Galwey, Godfrey, Harold, Hasting and Nihill etc. Their influence on the physical aspects of the area is recalled in the name of the city's oldest building – the lax weir – at Corbally, the remains of which are still visible, lax being the Scandinavian word for salmon; and in Quay Lane, now Bridge St., quay is the old Norse term for a narrow street or laneway leading to the waterfront. The square tower of St. Mary's Cathedral may also, according to some scholars, have a resonance in Viking age architecture.

There is an interesting account in Maurice Lenihan's *History of Limerick* of a note written in 1793 by Ralph Ousely Esq., M.R.A., which states *"Mr. Walker, a member of the Royal Irish Academy, has an Icelandic manuscript date in 1010, which mentions Rafer, a merchant, an Icelander, who had resided many years in Limerick"*. This merchant's memory is perpetuated a thousand years later, in the recently built elegant apartment block at Locke Quay called 'Rafer's Court'.

There is a long standing tradition in the city of an early connection between Iceland and Limerick. One of the main reasons for this belief apparently was the strong attraction for the red-haired women of this area, that the Icelanders held. Certainly, this belief could be very easily inferred by the account in Magnus Magnusson's (of BBC fame) book, *The Laxdaella Saga*, of a young Irish girl of noble blood, Melkorka, who was kidnapped by a Viking raiding party from somewhere in the west of Ireland and brought back to Laxdaella in Iceland. Her father was a prince – *Myrkjartan, Muircheartach* in Irish.

Undoubtedly, however, the strongest Viking figure in the mediaeval city was Gilbert or Gille (c. 1070 - 1145), the first Bishop of Limerick and Papal Legate appointed by Pope Paschal the Second. He was a native of the city's Viking community according to his biographer, Monsignor John Fleming, Rector of the Irish college in Rome, in his book *Architect of the Mediaeval Church*. He presided at the Synod of Rath Breasail in 1111, which drew up the diocesan boundaries which have remained largely unchanged until the present day.

Viking Limerick
CORBALLY

36

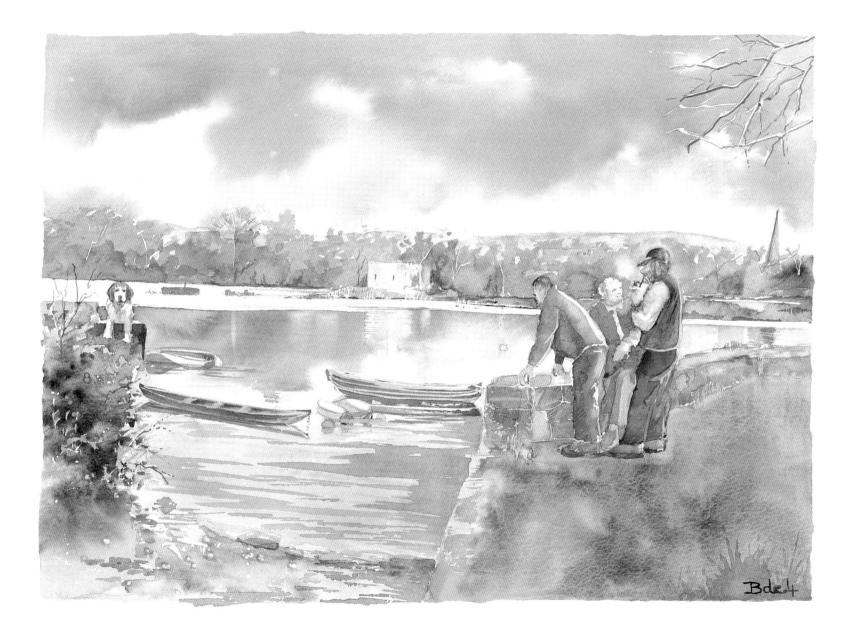

One of the most interesting descriptions of 19th Century Limerick was left by the author of *Vanity Fair*, the celebrated English novelist, William Makepeace Thackeray (1811-1863).

He visited Ireland in the summer and autumn of 1842 and described his experiences here in *The Irish Sketch Book*. He noted that "*The first aspect of Limerick is very pleasing; fine neat quays with considerable liveliness and bustle, a very handsome bridge (the Wellesley Bridge) before the spectator, who, after a walk through two long and flourishing streets, stops at length at one of the best inns in Ireland, the large neat and prosperous one run by Mr. Cruise*". He leaves us a vivid account of the people he saw there, the idlers, the young army officers, the troupes of women selling very raw green looking apples and plums, the dragoons in red clattering up "*this full and gay street with its bright red houses*".

His description of the women he saw there may well have been the origin of the city's long established reputation for beautiful women as he was then one of the best known Victorian era novelists of the English speaking world. He noted that "*in every car that passes with ladies on it you are sure (I don't know how it is) to see a pretty one.*" He goes on to say that if the ladies of the place were pretty, the vulgar (ordinary) were scarcely less so. "*I never saw a greater number of kind, pleasing, clever looking faces among any set of people*".

He noted that the women here seemed much better clothed than those in Kerry and that although many of them went barefoot, their gowns were nevertheless good ones and their cloaks were of fine cloth. This custom of going without shoes in summer was a popular one; two out of every five women he saw here were barefoot, a practice indeed which lasted among the city's schoolchildren down to the 1960s.

He was not, of course, the only distinguished foreign visitor to comment on Limerick's beautiful women. Sir John Carr, who came here in 1805, noted "*the bustle of trade in every quarter and fine coaches and pretty women everywhere*". US President John F. Kennedy on his visit to Limerick in June 1963, only a few months before his assassination, referred in his acceptance speech on being admitted to the City's Roll of Freemen to "*Limerick's reputation for fast racehorses and beautiful women*". This fact was long recognised in one of our oldest ballads, which says:–

Here's to Limerick famed o'er all,
For its well defended wall
But still more, for the beauty of its lasses.

A noble legacy indeed.

Thackeray's Limerick
O'Connell Monument

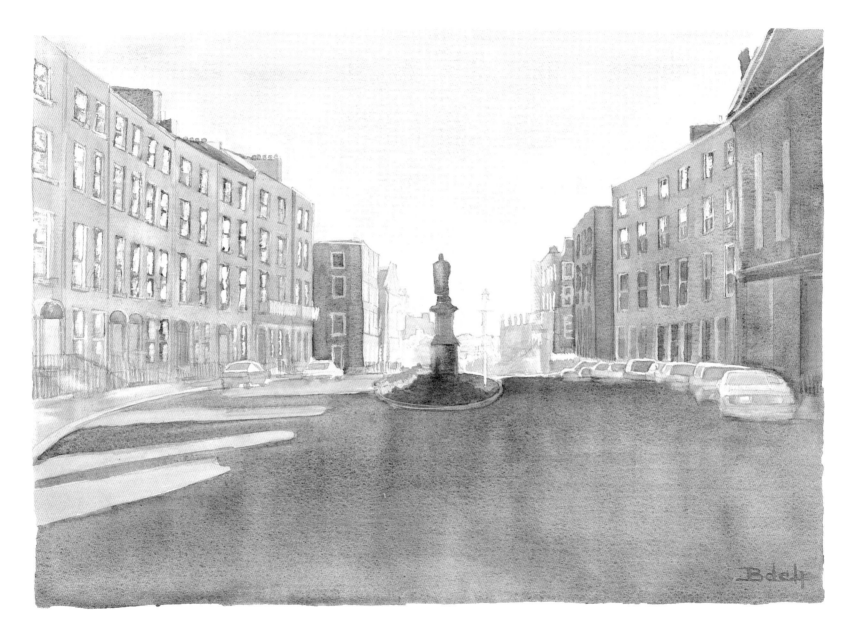

The Treaty Stone, Limerick's historic symbol, was brought according to local tradition from its original location at Redgate in the City's Northern Liberties, to serve as the table platform on which the Treaty of Limerick was signed on 3rd October 1691.

This marked the end of the wars in Ireland between the armies of William III of England and his father-in-law James II, which had their origin in the revolution of 1688 which forced the latter to abandon the throne of England, Scotland and Ireland to William and Mary.

Europe was then divided with Louis XIV of France on one side opposed by the Grand Alliance of William, Austria and the Holy Roman Empire on the other. In Ireland, the Catholics supported James and Louis while the Protestants sided with William. After the defeat of the Boyne in July 1690, James fled to France and the Irish forces fell back on Limerick, which then had a population of about 5000. Early the following month, William's armies surrounded the City and opinion was divided amongst the Irish as to whether they should fight on or seek an honourable settlement, as they were not ready for a long siege. The matter was decided for them when Patrick Sarsfield, a cavalry officer with considerable experience in European campaigns, led a troop of six hundred horsemen on a commando raid to waylay and destroy, at Ballyneety in County Limerick, a train with ammunition and artillery for William's army, which had surrounded the City fourteen miles away.

In what has been described as *"the most daring episode in Irish military history"* they attacked and slaughtered many of the sleeping cavalcade, piled the ammunition and cannons in a heap, and exploded them. The explosion, which was heard with relief by the beleaguered Irish in the City, was a major setback for William. Although he breached the walls on the 25th August, he met with such fierce resistance in which the women of the City played a major part that he went back to England and never returned to Ireland.

The following year however, the English army under the Dutchman General Ginckel returned and besieged the City again on the 8th September. This lasted for a fortnight and the Irish suffered heavy losses, which led to low morale and differences between the Irish and French defenders. They sought terms for surrender and the treaty was signed on the 3rd October.

This period of Irish history left a legacy of bitterness which has a resonance in Northern Ireland to the present day. Hopefully, the healing process may be just beginning, with the implementation of the Good Friday Agreement under the aegis of the Irish and British Governments.

The Treaty Stone

THE TREATY STONE AND KING JOHN'S CASTLE

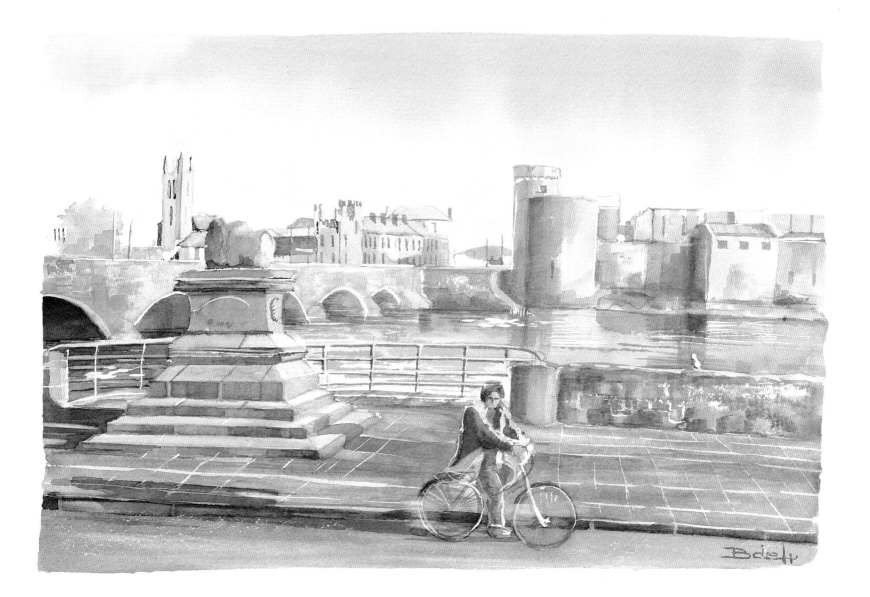

The campaign for a University for Limerick began with the passing of the Bill in 1845 to establish the Queen's Colleges in Ireland. The country then had only one University, Trinity College Dublin, which was founded in 1593.

Limerick interests felt strongly that one of the proposed colleges should be located there because of its location, economic status and its early reputation in the field of higher education. Despite a rigorous and sustained campaign, however, led by the former MP William Smith O'Brien, the Government decided to locate the Colleges in Belfast, Cork and Galway. But their claim proved beyond doubt, that there was a very strong desire in Limerick for its own University.

Very mindful of this, the Past Pupils' Union of the City's Sexton St. Christian Brothers Schools revived the campaign in the 1950's. It was driven by the practical vision of a carefully selected Committee, all of whom had experience in public affairs and their efforts were acknowledged by the Government's agreement in December 1968 to establish a third level educational institute in Limerick.

A Planning Board was appointed with a brilliant young Cork born engineering graduate of the Massachusetts Institute of Technology as Director, Dr. Edward M. Walsh. His selection can truly be described as having been inspired as he has since emerged as one of the greatest figures in 20th century Irish education, whose radical vision has transformed the national academic scene.

Some evidence of this imagination for example, was the selection of the campus at Plassey House, a former residence of Baron Clive of Plassey – Clive of India – in a spectacularly beautiful parkland estate on the River Shannon, three miles above the City. This campus, with the generous help and foresight of Shannon Development whose former Chief Executive Paul Quigley was a member of the Planning Board, has now grown to one of two hundred acres. This, in turn, is the focal point of the National Technological Park, six hundred acres in extent, which has attracted over 650 different organisations, which interact in different ways with the teaching, research and cultural activities of the University.

The new National Institute for Higher Education opened its doors in 1972 and was established as one of the first Universities in the history of the state, under the University of Limerick Act on 22 June 1989.

The University's establishment has been described as a major event in Limerick history. Its influence on Limerick and Irish affairs is likely to grow over the centuries to an extent undreamt of by William Smith O'Brien and his fellow visionaries.

University of Limerick
UNIVERSITY OF LIMERICK

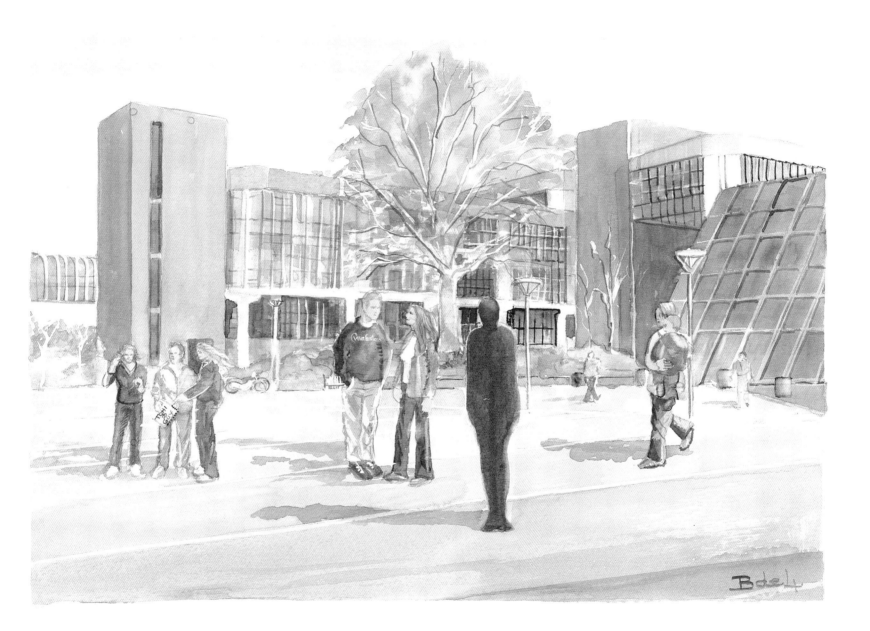

Limerick City, although it has had something of a mixed bag in terms of what visitors thought about it from earliest times, has, by and large, given a good impression of itself. Several of the earliest commentators were very favourably impressed by its location on an island, known then as Inis Sibtonn or Ibdan.

Certainly, it must have impressed those second century visitors who sent their reports back to the Greek cartographer Ptolemy, at Alexandria in Egypt, because he identified it, according to some scholars, as Regia on his map of Ireland in 150 AD A thousand years later, Geraldus Cambrensis, or Gerald the Welshman – no great lover of Ireland – described Limerick as *"that noble city encircled by the River Shannon"*. There was then of course, no Irishtown until the 15th century.

The English antiquarian, Thomas Dinely, in his *Tour of Ireland* in 1680, has left a very good description of the city. He said that *"the city walls were fair and strong, with a paved walk thereon as are those of Chester and Shrewsbury in England"*. He noted that the houses were very strongly built, up to five feet thick, *"the cellars were dug deeply; the city gates were locked every night and the keys given to the Governor"*.

Later on of course, following the development of the Irishtown and the building of what was a new town in the 18th century by Edmund Sexton Pery – Newtown Pery – the mediaeval town, the English town, fell into disrepair. Many of the comments later were on these two lines, the older city now in decline was criticised and the Georgian Pery development lauded.

This was before the truly resplendent face change given to the city by the then City Manager Jack Higgins and Jim Barrett the City Architect, under the Urban Renewal Programme in the 1980s & 1990s. This has cost almost IR£ 600 million in tax incentives and private investment, and has transformed the city's architectural image by facing the city towards the River Shannon.

Mayor Thady Coughlan remembers that during a visit to the Vatican in his Mayoral year (1975-1976), Pope Paul VI recalled his visit to Limerick as Cardinal Montini. He had stopped at Shannon Airport en-route from America to Rome and remembered distinctly *"the beautiful building on the main bridge across the Shannon"*. He was of course referring to one of Limerick's most beautiful buildings, Shannon Rowing Club.

As Others See Us
SHANNON ROWING CLUB

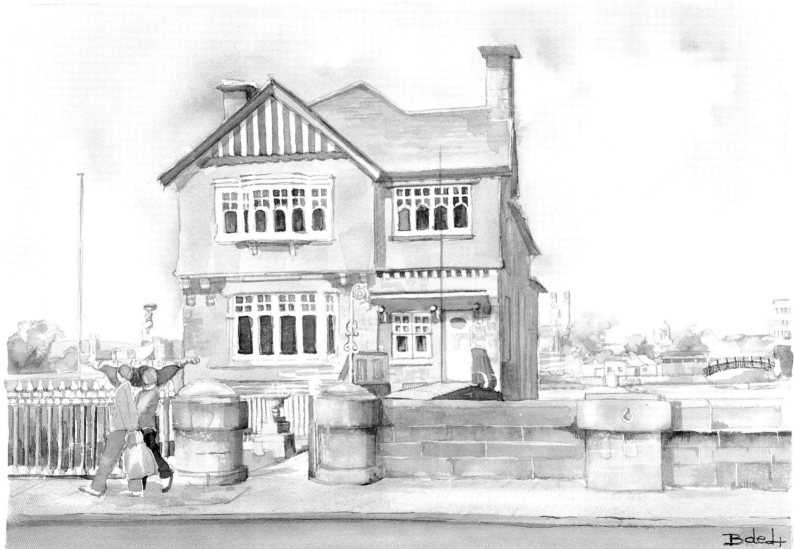

Even its readiest detractors have agreed that the city has undergone an architectural sea change from what it was up to the 1980s. Under the enlightened vision of two Cork men, Jack Higgins, City Manager and Jim Barrett, City Architect, optimum advantage was taken of the generous Government funding available under the urban renewal Programme introduced by the 24th Dáil in the 1986 Finance Act. Of the 280 derelict sites in the city then, all but twelve have been replaced and these will have gone also when the present Integrated Area Plan is finished in 2004.

The essence of Barrett's vision was to use the Shannon as the basis on which to upgrade the city by facing the new developments toward the river. Pride of place in this scheme was given to the magnificent Civic Centre, which incorporates the new purpose-built City Hall and City Courthouse on the riverbank, the refurbishment of the old Potato Market, formerly the city's mediaeval harbour, and the County Courthouse. All of these complement the most elegant of all the city's ancient landmarks, St. Mary's Cathedral (1168) to the north of the Merchants Quay Square, thus bringing back to life what was the heart of Viking Limerick a thousand years ago. The Sylvester O'Halloran (1728 – 1807) foot bridge, which commemorates the legacy of one of the city's greatest surgeons and scholars who lived there, links these developments with the beautifully restored Hunt Museum and Park and the newly built imposing offices of the Revenue Commissioners across the Abbey River in Francis Street.

All this development is now bounded to the northwest by the recently constructed Marina, into which flows the Abbey River, and which has floating pontoon jetties with room for 27 craft. Each of these jetties has been provided with marina lighting, water and power plants for visitors. This navigation facility opens up the entire Shannon for boating enthusiasts all the way from the Atlantic Ocean to the Erne in County Fermanagh. It is the culmination of a vision first mooted in 1820 by the engineer Alexander Nimmo, but which had to be deferred for lack of money.

Civic Centre
CURRAGOUR FALLS AND CIVIC OFFICES

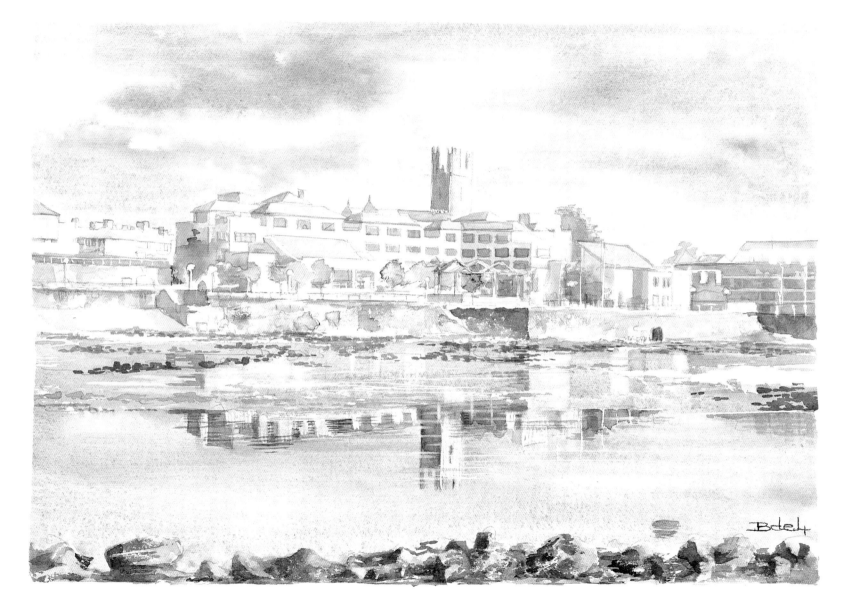

Even allowing for the spectacular new building developments that have taken place in Limerick under the Government's imaginative Urban Renewal Scheme in recent years, few of its citizens would dispute the viewpoint that its most imposing building is its mediaeval cathedral, the church of the Blessed Virgin Mary. Built in 1168 by Dónal Mór O Brien, it was one of the six churches and three cathedrals he built during his reign as King of Thomond or North Munster.

Tradition holds that it was built overlooking the City's mediaeval harbour on what was originally the Viking Thing – Mote or council chamber and courthouse, and afterwards the site of his former palace. Some scholars believe that its square shaped tower may have an architectural resonance in the Viking age. In any case it has served the people of Limerick well for over eight centuries as a centre of continuous worship of God. Even though it has been the responsibility of the Church of Ireland since the Reformation, it is a source of great pride and affection for citizens of all religious persuasions.

It contains several very interesting historic features such as the Lepers' Squint on its western side. This consists of a narrow horizontal opening in the wall through which the Sacred Host was passed on a wooden pallet at Holy Communion during Mass, to the lepers outside who were forbidden to enter the church in their sad condition. This custom was also common in other churches throughout Europe.

Another unusually interesting feature is the black oak 15th century 'misericords' or choir stalls used by the clergy during the long ceremonies. Sitting was forbidden but they would lean back for support on stalls or crutches and the 'misericords' – from the Latin word for mercy, were designed ingeniously to allow the clergy sit on a narrow ledge in the seat while giving the congregation the impression that they were really standing. Similar examples can be seen elsewhere in Europe, notably in Spain.

Still another fascinating feature are the recesses and stone surrounds which were built by Michael Pearse, the stonemason father of the two executed patriots of the Easter 1916 Rising, Willie and Padraig Pearse. The cathedral which is presently undergoing an extensive renovation programme with civic and Government financial support is one of the City's major tourist and cultural centres.

St. Mary's Cathedral
ST. MARY'S CATHEDRAL

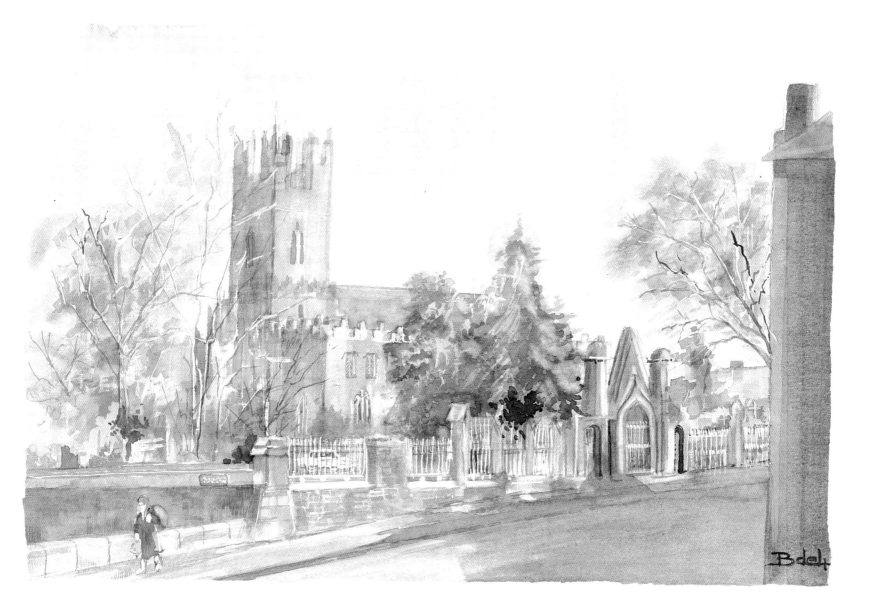

Where have all our bows gone? One of the sad casualties of the changes which have taken place in recent years is the degree to which many old types of street names have gone out of fashion. Some of those mentioned in the Civil Survey (1654) were hundreds of years old and survived well into the 20th century, until the new housing estates changed the landscape.

The older types of names which have been abandoned, included, Lanes, Alleys, Rows, Ranges and Bows. The 'in' terms now are; Avenue, Drive, Gardens, Park and Court, which may be due to the belief of builders and developers that these more upmarket names will get them higher prices. Some of them are known to knock down mature trees and then call the streets of their new estates after them.

One particular casualty was the name 'Bow', the etymology of which is hard to trace. It would appear to be due to their lay out, where a house or building spanned the street, hence, presumably the image of an arch or bow. Some of the old Bows were named after those who built them, e.g. Foxe's, Clampett, Meehan, Anglam etc., and others after local landmarks, such as Meat Market Bow.

One such Bow, Clampett's, was located in a lane off John Street, opposite where the ever popular Ford's chip shop now stands. This Bow achieved great notoriety from a 'siege' which took place there on 2 March 1879. The previous Sunday, the first in Lent that year, was 'Chalk Sunday'. A very strong local custom then was that bachelors had chalk marks put on their coats if they had not married before this Sunday. One such young man resisted this, and a fracas ensued involving the RIC. The culprits fled to Clampett's Bow and locked themselves into a house there from which the police took two days to dislodge them. A local journalist, Thomas Stanley Tracey wrote a satirical poem *The Battle of Clampett's Bow* which presumably did not promote a good image of the Bows.

One of the very few remaining here now is Foxe's Bow, between William Street and Thomas Street. It is called after the popular hotel and tavern owned by the Foxe family. It spanned the lane there and is one of the best examples of its kind.

Where have all the Bows Gone?

FOXE'S BOW

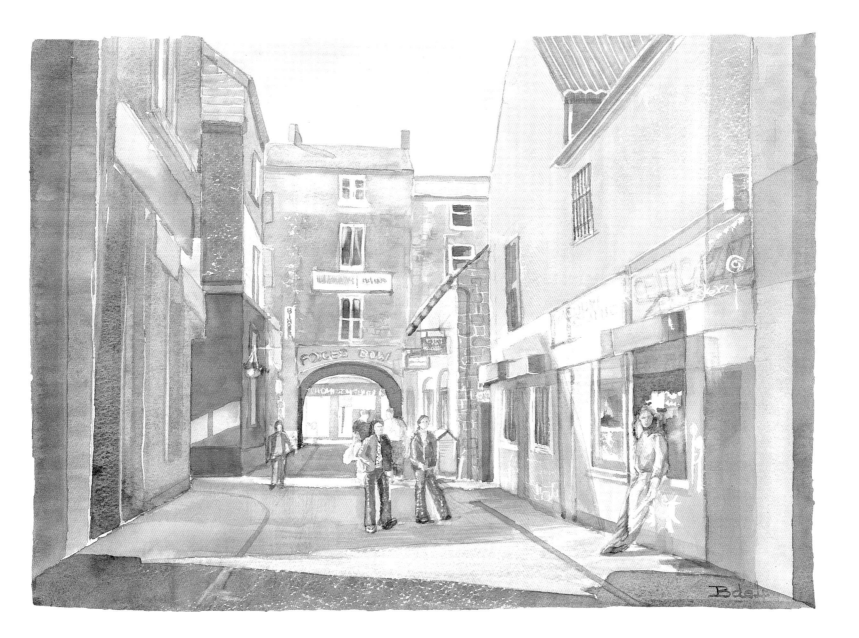

The pretty village of Castleconnell, situated on a narrow strip of Co. Limerick that pushes northward between Clare and Tipperary, has a magnificent setting on the banks of the Shannon, the great river flowing past the village in a series of broad curves. Delightful views of the river can be obtained if one strolls along the road, past the now disused chalybeate spa, which once attracted the fashionable from far and near, and past the spot where a well known hostelry called Worral's Inn once stood. Perhaps it was because it stood at the end of the roadway, or perhaps it was because people mistook the sound of the name, that Worral's Inn, and the area in which it stood, became known as 'World's End'!

Close beside you as you stroll along the road in question, Ireland's greatest river flows broad and smooth between its wooded banks, while out in the peaceful water swans float with a languorous grace. One of the most famous sights in the Castleconnell area was the Doonass cataract, more popularly known as the Falls of Doonass. The name Doonass comes from the Irish *Dún Easa*, meaning 'the fort of the waterfall', an ancient fortress obviously having once been located in close proximity to the Falls. However, the Falls are now but a shadow of what they were. The lowering of the level of the Shannon in the 1920s, resulting from the cutting of a canal to take water from the river to the new hydroelectric generating station at Ardnacrusha, near Limerick, made the Falls of Doonass a far less spectacular sight than they had been.

In the 18th and early 19th century it was its spa, already mentioned, that attracted visitors to Castleconnell but in later times the fame of its angling completely overshadowed the fame of its spa, and numerous villas were built in the vicinity of the village by those who came there regularly to fish. It is still a favourite place for fishing. Fishing rods of a very high quality have been made there for generations, and the greenheart Castleconnell two-piece spliced salmon rod enjoys an international reputation. John Enright, of Castleconnell, member of a family that made those rods in recent times, set up a world record for fly-casting.

Castleconnell, some eight miles north-east of Limerick city, still maintains a character all its own and many of its people engage in literary, musical, artistic and sporting pursuits. It also has a strong Gaelic tradition. It is an attractive village to ramble through at any time, but especially in the summertime when the sun adds its magic to the scene.

Castleconnell
- for beauty and fishing
SHANNON AT CASTLECONNEL

The Shannonside district in which the attractive and historic village of Castleconnell is situated originally belonged to the old Gaelic family of O'Conaing, which explains why the original name of the village was *Caisleán Uí Chonaing*, 'the Castle of the O'Conaings'. The old name was misleadingly anglicised as Castleconnell, but no Connell, or O'Connell, ever held the place.

After the Norman invasion, Castleconnell, and a large surrounding area, passed to the powerful Norman family of de Burgo, a name that later became Bourke or Burke. It was the de Burgos who built the castle, the ruins of which one sees on the outskirts of the village when coming from the Limerick city direction. The castle, perched high on a great rock, gives a commanding view of a long stretch of the Shannon. William Lord Burke, Baron of Castleconnell, described as 'Irish Papist' in the Civil Survey of 1654, was the last de Burgo, or Burke, to own Castleconnell. He was deprived of all his lands at the time of the Cromwellian confiscations and plantations.

There would seem to have been strange goings on in the old de Burgo castle at Castleconnell in the August of 1640, if we are to judge by a letter written by a Mr Holmes of Limerick to the Archbishop of Armagh, of which the following is an extract:

"For news we have the strangest that ever was heard of, of enchantments in the Lord of Castleconnell's Castle, six miles from Limerick, and several sorts of noises, sometimes of drums, and trumpets, sometimes other curious music, with heavenly voices: then fearful screeches, and such outcries that the neighbours near it cannot sleep. Priests have adventured to be there, but have been cruelly beaten for their pains, and carried away they know not how – some two, some four miles. Sometimes minstrels, at other times armed men, as well on foot or horseback, do appear … Mrs Mary Burke, with twelve of her servants, lie in the house, and never are hurt …"

After the defeat of the Irish forces supporting King James II in 1691, Ginckel, King William's Dutch general, blew up Castleconnell castle, leaving it the great wrecked structure it is today.

While by far the greater part of Co. Limerick is in the diocese of Limerick, with a considerable part of East Limerick in the diocese of Emly, now episcopally united to the Archdiocese of Cashel, Castleconnell has the distinction of being the only Co. Limerick parish in the diocese of Killaloe.

Castleconnell
- its history
CASTLECONNELL VILLAGE

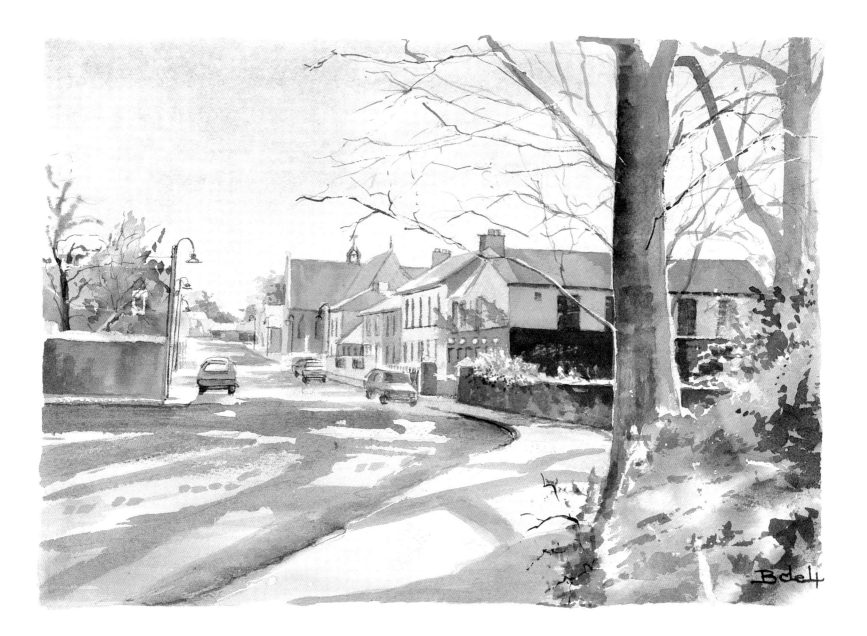

Since 1689 the Jacobite-Williamite War had been raging in Ireland. After the defeat of James II at the Battle of the Boyne and his subsequent flight to France, the Irish forces had fallen back on the line of the Shannon. In August 1690 Limerick was under siege by a large Williamite army. In the early days of that month news had reached the Irish camp at Limerick that a 'siege train' of more than 150 wagons, laden with big guns and all kinds of stores of war, was on its way from Dublin for the Williamite forces besieging the city.

Patrick Sarsfield was in charge of the Irish cavalry. A brilliant cavalry general, he had trained in France under a great master, Turenne. Sarsfield decided to intercept and destroy the siege train. At dusk on the night of Sunday 10 August, with six hundred men, he rode out from Limerick city, travelled northwards across the Clare hills, forded the dangerous and swift-flowing Shannon above Killaloe, rode northwards for a little while, then wheeled southwards and travelled through the Silvermines and Slieve Felim Mountains, and lay in wait for his quarry while his spies went reconnoitring.

The spies discovered that the siege train had stopped for the night at Ballyneety, a place on the extreme east of Co. Limerick, bordering on Tipperary. And they discovered something almost unbelievable – that the password at the Williamite camp for the night was 'Sarsfield'! Sarsfield, *'grá ban Éireann'*, 'the love of the women of Ireland', was tremendously popular among the Irish, and, strange to say, he was also highly respected by his opponents.

Before dawn on the 12th he and his six hundred swept past the startled sentries, answering the sentries' call for the password – so we are told – with the cry, *'Sarsfield is the word – and Sarsfield is the man'*! In a matter of minutes the camp was captured. All its guns and ammunition and food supplies were gathered into a mighty heap. A train of powder was laid, the match was applied, and the great heap was blown to smithereens. Limerick was saved – at least for the present. Percy French recalled the event more than 200 years later: –

And Ballyneety's blackened tower
Still marks that famous place
Where Sarsfield staked his all to win –
And won that midnight race.

Sarsfield's Ride
THE CLARE GLENS

Abington, a small place about eight miles east of Limerick city, was named 'Wothenya' in 1205 and 'Wotheney' in c1217. Both names were attempts to render phonetically the Irish name *Uaithne*, the pronunciation of which would to-day be most nearly approximated by the spelling 'Oon-neh'. Uaithne was, in fact, an ancient territory, still represented by the barony name Owney.

A Cistercian abbey founded in Uaithne in 1205 by the Norman, Theobald Fitzwalter, became known as *Mainistir Uaithne*, meaning 'the Abbey of Uaithne'. Fitzwalter was a nephew of Thomas a Becket, murdered Archbishop of Canterbury; the office of the English King's Butler in Ireland was later conferred on him, and he became head of the powerful Butler House of Ormond. Mainistir Uaithne, later called in English the Abbey of Owney, was one of the most important monasteries in the South of Ireland. It was suppressed at the time of the reformation.

Later, the abbey was demolished, and Abington House was built with the materials, so that not a stone upon a stone now remains of the ancient monastic building. The site of the abbey was in the old burial ground of Abington. With the passage of time, and through the process of Anglicisation, the name Mainistir Uaithne, or Abbey of Owney, took the present form Abington, which, apart from being the name of the townland in which the abbey was situated, is also the name of the Church of Ireland parish that includes the townland.

The present Church of Ireland parish church was opened for divine worship on 7 November 1870. According to *Inspiring Stones* (A History of the Church of Ireland Dioceses of Limerick, Ardfert, Aghadoe, Killaloe, Kilfenora, Clonfert, Kilmacduagh and Emly): *"Externally in appearance the building has been described as 'similar to a mini-cathedral', and its intriguing spire adds both grace and curiosity to the structure. The interior is striking, ornate and unusual, definitely an architectural gem; rectangular in shape, red brick was used in its construction".*

Referring to Caleb Powell, High Sheriff of Co. Limerick in the mid 19th century, who lived near Abington, *Inspiring Stones* has this to say *"Perhaps it is appropriate that such an ecumenist should live in a parish that has within its boundaries that great ecumenical centre (the Benedictine Abbey) of Glenstal. It could be said that the story of Abington has been based upon ecumenism with the nineteenth century Rector speaking in the local Roman Catholic church, and its nineteenth century parishioner supporting Fr Matthew and Daniel O'Connell. Altogether, a strong background and a parish worthy of its associations with Glenstal's major Ecumenical Conference".*

Abbington
- its Abbey and Church
ABBINGTON CHURCH

There is a famous saying used widely in Co. Limerick to express doubt. A person might say, "I think Paddy means to get married soon". To which the person addressed might reply, "'I doubt it', says Croker".

John Croker belonged to the 'landed gentry' class and had a large estate and a fine mansion at a place called Ballynagarde, about six miles south of Limerick city. He was popular with the local people, and was a keen follower of the hounds. He had a great love for Ballynagarde, and for the happy life he enjoyed there. But, in due course, old age began to creep up on him, and he became seriously ill. As it happened, a meet of the hounds had been arranged to take place at Ballynagarde just at that time.

Being aware of this, John Croker made his way slowly and painfully to the hall, where he was found seated, hunting horn in hand. He wanted to see and hear the hounds, and asked to be brought to a window where he'd have a good view of them. Having looked through the window for some minutes, he sighed. "O sweet Ballynagarde, must I leave you"? said he. His son, Robert, a clergyman, heard him and said; "You are going to a better place, father". "I doubt it", said Croker, coining the immortal saying that has ever since kept his memory alive.

A song composed about Croker said:

He made his own whiskey; he brewed his own ale,
That foamed up like beestings, that thick in the pail;

No fiddler, no beggar, nor gent with his card,
Was ever sent empty from Ballynagarde.

The incident of his clergyman son's assurance to him that he was going to a better place is referred to in another stanza;

He tried to persuade him to make him resigned
On heavenly mansions to fasten his mind:
"There's a land that is fairer than this you'll regard" –
"I doubt it", says Croker of Ballynagarde.

In their day the Crokers owned the whole of the parish of Cahercorney. The old Church of Ireland parish church had a handsome monument of the Croker family erected in 1723. The Crokers have, however, long since left Ballynagarde. Ballynagarde House, then unoccupied, was occupied by units of the Irish Army during the Emergency Period of World War II, 1940 to 1945. Today, the house is a ruin; but that saying uttered nearly 200 years ago by John Croker still survives on the lips of people. Will it eventually be forgotten?

"I doubt it", says Croker.

Ballynagarde and the Crokers
Ballynagarde House

Lough Gur, situated some ten miles south of Limerick, apart from being Limerick's only lake, is one of the, most important archaeological sites in Ireland. It is believed that Mesolithic people had reached here by 5000BC; and, of course, it has a rich Neolithic legacy. Some thirty ancient sites lie within the immediate area of the lake. These include megalithic tombs, stone circles, hut sites, forts, crannógs (lake dwellings), galláin (standing stones), ancient roads and fields, castles and caves. Its most important monument of the past is the great stone circle in the townland of Grange, 46m (150ft) in internal diameter, and the largest stone circle in Ireland. The total number of artefacts found in the area is quite impressive, and include objects of bone and flint, some 120 stone axes, numerous bronze axes and spearheads, and large quantities of prehistoric pottery.

In later times Lough Gur formed part of the huge estates of the Geraldine, or Fitzgerald, Earls of Desmond, who had two castles in close proximity to the lake, one of which is still in an excellent state of preservation. Many strange stories are told about Lough Gur, and the chief figure who features in the stories is Gearóid Iarla (the Earl Garrett), Fourth Earl of Desmond, a poet in Irish and French, who died at Newcastle (now Newcastle West) in 1399.

According to folklore, Gearóid also dabbled in magic, and that was his undoing, for, as a result of these activities, he is now held in captivity under the waters of the lake. Every seven years, however, on moonlight nights, he rides across the surface of the lake on a white steed shod with silver shoes.

When the shoes shall have been completely worn away Gearóid will be free to return to the world of mortals. About one hundred years ago, during one of his septennial appearances, Gearóid approached the shore of the lake where a man was standing, and he asked the man to look at his horse's shoes, and to tell him how worn they were. According to the story, the man looked, and told Gearóid they were worn as thin as an old sixpenny piece.

Lough Gur draws large numbers of people most of the year round because of its archaeological and scenic attractions. It is a bird sanctuary, and some rare plants grow there. A book, *The Farm by Lough Gur,* that Mary Carbery wrote in 1938, about an O'Brien family who lived near the lake, gives a fine account of the life of a farming family, albeit a well-to-do family, in that part of Co. Limerick at that time. In an interpretative centre – which is a replica of two conjoint Neolithic houses, one circular, the other rectangular – there is an audio-visual presentation of the archaeology and history of Lough Gur; also a small museum and bookshop.

Lough Gur

LOUGH GUR

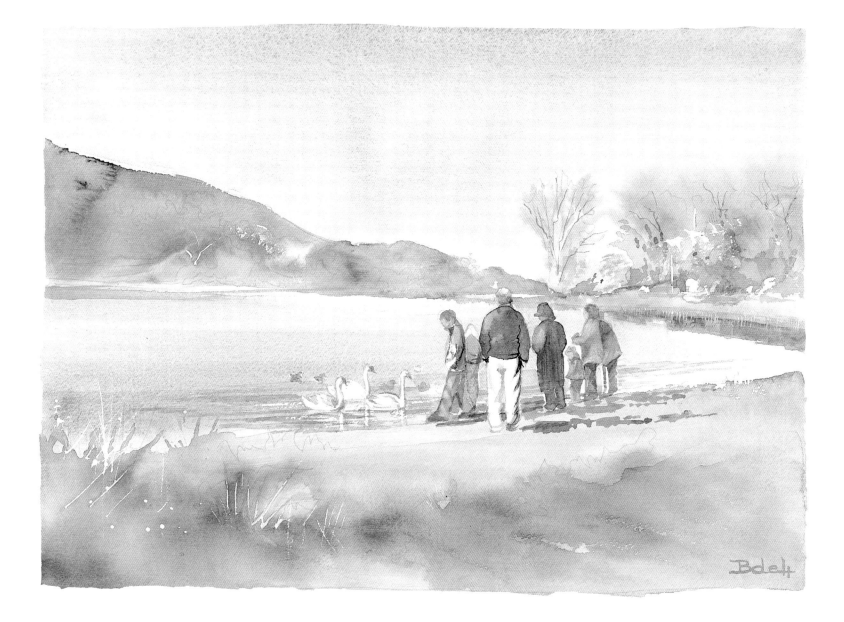

Though practically everybody spells the name of the place Manister, and though we are following their example in this present piece, the official spelling of the name is Monaster, which is a closer phonetic rendering of the original Irish name than today's popular spelling.

Manister, situated about two miles east of Croom, is famous as being the site of an important Cistercian Abbey, the ruins of which stand on the banks of a small river called the Camóg, or Camoge. The official name of the civil parish in which Manister is situated is Monasteranenagh, which is a corruption of the old name, *Mainistir an Aonaigh,* 'the Abbey of the aonach'. In modern Irish, the word *aonach* means a fair at which animals are bought and sold. Originally, however, it meant a public assembly of all the people of a *tuath,* a tuath being a kind of petty kingdom, of which there were about one hundred and fifty in ancient Ireland.

An aonach was held periodically in each tuath, and at it matters of public interest affecting the tuath were discussed; disputes were settled; goods were bought and sold; and athletic exercises and sports of all kinds took place. Judging by its name, it was on the site of such an aonach that Manister Abbey was built for Cistercian monks in 1148 by Donncha Ó Briain, King of Thomond (North Munster). The Abbey, soon to become one of the most renowned in Ireland, supplied the original community of monks for Holy Cross Abbey in Co. Tipperary, now happily restored as a parish church.

The Manister district is closely linked with the tragic story of the Colleen Bawn – a descriptive name from the Irish, *cailín bán*, meaning 'fair', or 'beautiful girl'. Her real name was Eileen Hanley, and she had grown up with her uncle on a small farm near Manister. One day in 1819 she was lured away from home by a Lieutenant John Scanlan, of the Royal Navy, who went through the form of a mock marriage with her. Scanlan had an accomplice in the business, one Stephen O'Sullivan, from Glin.

The Lieutenant tired of Eileen soon after and the next thing that was heard of her was that her body had been washed up on the Shannon shore, near Killimer, on the Clare side of the estuary. Evidence was given, that some days before, Scanlan and O'Sullivan were seen crossing in a boat from Glin towards Clare, accompanied by Eileen. Both men were tried for murder, found guilty and hanged. The fate of Eileen was to provide the theme for a novel, a play and an opera. The novel, The Collegians, was written by Gerald Griffin, in 1828; the play, The Colleen Bawn, by Dion Boucicault, in 1860; the opera, The Lily of Killarney, by Julius Benedict, in 1862.

Manister

MANISTER ABBEY

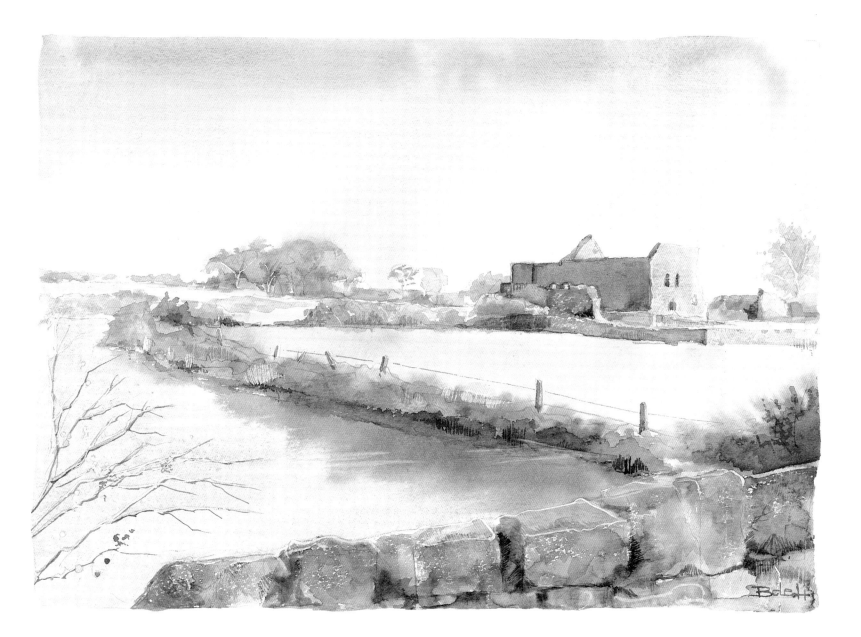

Croom is celebrated for a school of Gaelic poetry that used to meet there in the 18th century. The poets were known as *Filí na Máighe,* the Poets of the Maigue. It was customary for the poets to come together in the tavern of Seán Ó Tuama (anglicised O'Tuomy), himself a poet. Up to a dozen poets might be present at any of these sessions, and they were always treated hospitably by the tavern keeper, Seán. Realising that composing poetry was not a very profitable business, especially in 18th century Ireland, Seán had a welcoming notice in verse placed over his door offering free drinks to penniless poets.

The poet who availed himself most frequently of Seán Ó Tuama's generous offer to poets was Aindrias Mac Craith, equally well known by his soubriquet *'An Mangaire Súgach',* meaning 'the Merry Pedlar'. Aindrias, however, was not a pedlar, but a schoolmaster, who set up school from time to time in different places. One day, when the poets were assembled at a poetry session in Ó Tuama's tavern, Seán tossed off an impromptu piece of verse in Irish which Clarence Mangan translated as:

> *I sell the best brandy and sherry*
> *To make my good customers merry,*
> *But at times their finances*
> *Run short as it chances,*
> *And then I feel very sad, very.*

Aindrias (Andy) was not at all pleased with Seán's lines, as he believed they were intended for him, and referred to all the unpaid for drinks he had consumed. His reply was sharp and bitter. Mangan's translation is as follows:

> *O Tuomy! You boast yourself handy*
> *At selling good ale and bright brandy,*
> *But the truth is your liquor*
> *Makes everyone sicker,*
> *I tell you that, I, your friend, Andy.*

And he went on:

> *Both your poems and pints, by your favour,*
> *Are alike wholly wanting in flavour,*
> *Because it's your pleasure*
> *You give us short measure,*
> *And your ale has a ditch-water flavour.*

Anybody with any knowledge of versification, will notice that the stanzas are in Limerick form. It has been suggested that the Limerick form of verse was so named because it was first popularised in Co. Limerick by the 18th century Irish-speaking Poets of the Maigue.

Croom and the Limerick
Croom Mills

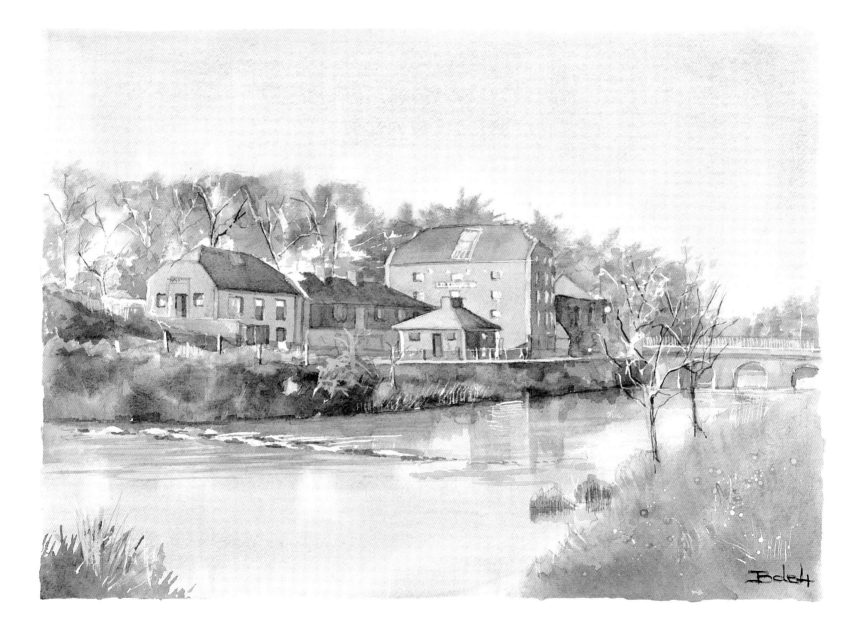

The name of the beautiful village of Adare tells of woods and water, for it comes from *Áth Dara*, meaning 'the ford of the oak'. The ford was on the Maigue, near where the bridge now stands. The original owners of the district where Adare is situated were the O Donovan, whose headquarters were at Bruree, and who were lords of all the country *'fan Máigh moill is na cláir síos go Sionainn'*, along the slow flowing Maigue and the plains down to the Shannon.

After the Norman invasion the Adare district came into the possession of that branch of the Fitzgeralds whose head subsequently bore the title Earl of Kildare. For a village of its size, Adare must be unique in having had three abbeys – the term 'abbey' is, of course, commonly used in Ireland to describe all medieval monasteries, even though some of them should properly have been described as friaries or priories.

The first abbey in Adare was founded about the year 1230 for the Trinitarian Canons of the Order of Redemption of Slaves. The main purpose of the Order was the redemption of Christians captured by the Moors. Adare was the only house of the Order in Ireland. It was suppressed at the time of the dissolution of the monasteries and gradually fell into decay.

The Augustinian friary was founded in 1315 by John, son of the Earl of Kildare, and again, it, like the Trinitarian abbey, was suppressed at the time of the Reformation. Adare's third monastery was founded in 1464 by Thomas, Earl of Kildare, and his wife, for the Franciscan friars of the Strict Observance.

Of all their monasteries in Munster the Franciscans regarded that at Adare as the loveliest. But within a hundred years of its erection the Reformation came and it was suppressed. Its well-preserved ruins are located in beautiful woodland setting in the grounds of the Adare Manor House Hotel close to the river Maigue.

In 1807 the first Earl of Dunraven restored the Augustinian friary and gave it to the local Protestant community as their parish church. Four years later he restored the Trinitarian abbey and handed it over to the Catholic community as their parish church. Both churches still serve these purposes.

Adare castle, of which an excellent view can be obtained from the nearby bridge over the Maigue, is considered one of the finest examples of feudal architecture in Ireland. The Dunravens – the family name is Wyndham Quin -, so closely linked to Adare in recent times, came to Adare in the second half of the 17th century, and leased a large tract of land from the Earl of Kildare; Thady Quin purchased these lands outright in 1721. Edwin Quin, who became a Member of Parliament, voted for the Union in 1800, and was rewarded for his action by being elevated to the peerage as Lord Adare and Earl of Dunraven.

Adare - its history
Adare

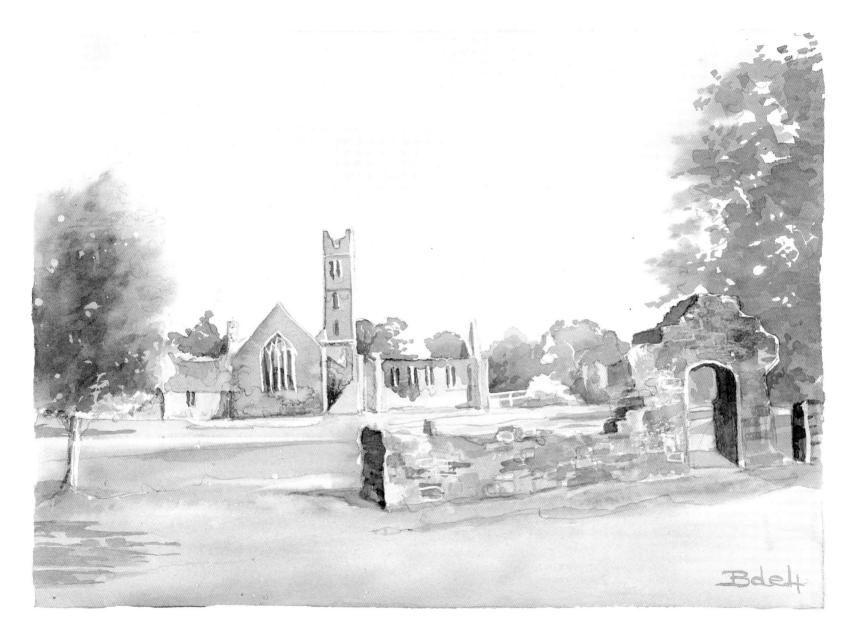

Adare, a dozen miles or so southwest of Limerick city, and situated on the river Maigue, is widely claimed to be Ireland's loveliest village. Water and woodlands, beautiful ancient buildings, and picturesque thatched cottages combine here in a rare loveliness. The view upstream from the Maigue bridge is one of the fairest in Ireland. Before you is the river, clear and smooth flowing, with the centuries-old castle of the powerful Fitzgeralds rising cliff-like from the water's edge. A little further upstream, framed in an opening in the woods, are the graceful ruins of a Franciscan friary. The Limerick city born poet, Gerald Griffin (1803-1840), who lived for a time in Adare, wrote beautifully of the place:

> *O sweet Adare, O lovely vale,*
> *O soft retreat of sylvan splendour,*
> *Nor summer sun, nor morning gale,*
> *E'er hailed a scene more softly tender.*
> *How shall I tell the thousand charms,*
> *Within thy verdant bosom dwelling,*
> *Where, lulled on Nature's fostering arms,*
> *Soft peace abides and joy excelling.*

> *There winds the Maigue as silver clear,*
> *Among the elms so sweetly flowing;*
> *There fragrant in the early year*
> *Wild roses on the banks are blowing,*
> *There wild duck sport on rapid wing,*
> *Beneath the alder's leafy awning,*
> *And softly there the small birds sing*
> *When daylight on the hill is dawning.*

The Adare described in the previous chapter, with its abbeys and castle, could be said to be the creation of the Fitzgerald Earls of Kildare from the 13th to the 16th century. Just as truly it could be said that modern Adare is, to a very large extent, the creation of the Earls of Dunraven. They left their distinctive imprint on the village, especially in the 19th century. There was the restoration by the First Earl of the Augustinian friary as the Protestant parish church, and his restoration of the Trinitarian abbey, a few years later, as the Catholic parish church. There are the much admired thatched cottages dating from 1828, and the eye-catching village hall; and, of course, there is the great manor house in Tudor Gothic style, with fireplaces, stairways and the magnificent grand gallery, 40m (132ft) long, designed by Pugin. Adare manor house is now the Adare Manor Hotel, having been sold some twenty years ago by the present Earl of Dunraven, who, with his wife, the Countess of Adare, still resides in the Adare district.

Adare - its beauty
ADARE VILLAGE

Travelling out from Limerick city to visit the site of a famous monastic establishment, your eye will be caught by the sight of Spillane's Tower, a small tower, close to the Shannon. Seeing it will tell you that you are on the right road to your destination.

Early Christian Ireland was famous for the large number of its great monastic schools which included Clonmacnois, Bangor, Lismore, Clonard and Mungret. Mungret is situated only a short distance south-west of the present city of Limerick, and its monastery is believed to have been founded some time in the 6th century by St. Nessan, who died in 551. As its fame as a seat of learning spread, students came in great numbers to study there, so that the original monastery had to be enlarged to cater for them, and to cater also for the many artisans and other kind of workers, who, with their families, settled within the monastery complex.

The story of the Wise Women of Mungret is well known. The learned monks of Lismore, feeling jealous of the growing fame of the monks of Mungret, sent the latter a challenge to meet them in scholarly disputation, which would take place at Mungret, and the Mungret men were not at all happy at the thought of an encounter with the intellectual giants of Lismore. But they were *glic,* ingenious, and devised a plan.

Shortly before the Lismore scholars were due to arrive, they dressed up a number of the most scholarly of their own community as old women, and had them washing clothes at a point in a stream which the visitors would have to cross as they approached Mungret. Eventually the Lismore monks came to where the 'women' were, and enquired in Irish how far it was to the monastery. One of the 'women' gave the information in fluent Latin. And when she had finished a second 'woman' gave the visitors further information in fluent Greek; and when the Lismore monks expressed their wonder at the 'women's' linguistic accomplishments, they were told that everyone in Mungret spoke Latin and Greek, in addition to Irish. If the ordinary people are so learned, said the Lismore contingent, what must the scholars in the monastery be like? And so, rather than be humiliated in the contest, they turned heel and headed back for Lismore.

Nothing of the original 6th century monastery of Mungret now survives, but there are the remains of three church buildings from a later date. The largest of these, a 13th – to 15th – century nave and chancel church, is situated in the burial ground; and a short distance to the south-east is the smallest of the churches, thought to be 13th century. The oldest of the churches is a little distance removed, and is to the left of the road from Limerick; it has a remarkably high west gable and a trabeated doorway with inclined jambs dating from the 12th century.

Mungret and its wise women

SPILLANE'S TOWER

Very soon after one has left Limerick city and headed southwards along the Kildimo-Foynes Road, one's attention is attracted by the very conspicuous outline of Carrigogunnel Castle which dominates the skyline to the north-west. The ruined castle stands high on the summit of a great basaltic rock, in itself a rare geological feature in this part of Co. Limerick.

The first castle on the rock, built by the Norman William de Burgo, later passed to the O'Briens, who replaced it with the present structure. Besieged and battered at various times, it surrendered in 1691 to King William's forces, who blew up its defences; this accounts for the massive blocks of masonry that strew the site.

During 1690 when the Irish forces of King James were in possession of Limerick, John Stephens, an Englishman, was with a company of Jacobite forces billeted in the Carrigogunnel area. In a journal he kept, Stephens tells of the hospitality of the local people. He says that they supplied the soldiers with plenty of meat and barley bread, baked in cakes over or before the fire, with abundance of milk and butter.

And we have a record of Carrigogunnel hospitality enjoyed more than a hundred years after that enjoyed by John Stephens and his comrades in 1690. This second account comes from a book written by G. Holmes, another Englishman, in a work called *Sketches of some of the Southern Counties of Ireland*, collected during a tour in the Autumn, 1797. In his book Holmes says:

"From this airy habitation, we descended, and going to the cottage for our horses, were surprised at finding a small table laid, on which were eggs, milk and potatoes. This humble fare was offered to us, with all the kindness of genuine simplicity and good-nature; for although we could not speak their language (Irish), still we could not mistake the meaning of their eyes, which spoke as much as the most energetic tongue could convey…"

The rock on which the castle stands falls sharply from the base of the castle at almost every point, accentuating the dramatic appearance of the shattered pile. The view from the top of the rock has been described as 'one of the great vistas of Ireland'. As the eye begins to roam over a patchwork of countless fields it is immediately arrested by the sight of the great Shannon gliding smoothly westward towards the sea. And looking eastward one sees the city of Limerick, some 7km (4 miles) distant.

Carrigogunnel

CARRIGOGUNNEL CASTLE

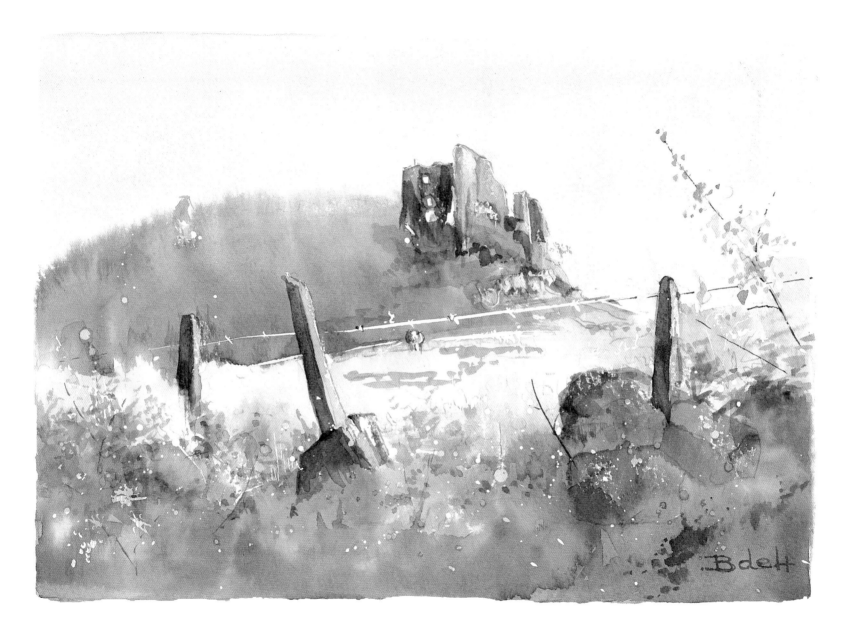

Limerick

-Ireland in the new millenium

In his excellent treatise on the history of King John's Castle *Anatomy of a Siege, King John's Castle Limerick 1642*, the noted archaeologist Kenneth Wiggins, reminds us that the historian Richard Stanihurst, who visited Limerick in 1584, speculated that "*King John, taken by the delightfulness of Limerick, ordered the construction of an eminent castle and bridge there*" (1210). He points out also that his own recent excavations confirm that there was a castle there even before the Norman Prince John built his castle, five years before he signed his famous Magna Carta at Runnymede (1215).

Apart from 'the delightfulness', its location was dictated by its proximity to the bedrock shelf of the nearby Curragour Falls, which is the first place in its sixty miles distance from the Atlantic, that the Shannon River can be forded at low tide. The limestone quarries across the river in Thomondgate were a plentiful source of building stone.

The castle and the cathedral (1168) nearby are the city's two great mediaeval symbols around which the people's lives have ebbed and flowed within earshot of the Shannon and its Abbey tributary for 800 years. The delightful mellifluous names of the ancient Gaelic townlands, Leantaun, Tannainluinge, Curragour, Farranshone, Corbally, and Lanahrone reflect the river's beauty as it flows through the ancient city. Commenting on this scene, Washington Irving (1783-1859), the great American novelist, who visited the city as part of his grand tour of Europe, described the view of the Curragour falls against the background of the Clare Hills as one of the most beautiful he had seen on his travels.

The discovery in 1997 of a 6,800 year old,

People & Place

sixteen-foot boat and human skull at Carrigadoarty in the mudflats below Clarina by the Office of Public Works archaeologists, tell us that there were people here thirty centuries before the pyramids were built in Egypt. Other recent discoveries at Castleconnell, Dooradoyle and Adare confirm this evidence from the Mesolithic Age, and enhance their 'mórtas cine', their legitimate pride of ancestry. The outlook of the present day Limerick people in the city and county is probably best summarised in the apt motto of Newcastle West, the County capital, *'As Dúchas Dóchas'*, which, not to translate too literally, means 'A future from our past'. This captures neatly, their intense pride of place and history and the ringing confidence of the younger, well-educated generation who are making such an impact at home and abroad in business, politics, religion and sport.

The more obvious examples of this include those of Pat Cox MEP, President of the European Parliament, a past pupil of Árd Scoil Rís Christian Brothers School; Niall Fitzgerald, Chairman of the giant multinational Unilever PLC, who grew up and was educated in the city; Monsignor John Fleming D.D., a native of Ardagh, recently retired Rector of the Irish College in Rome and now Bishop of Killala; in music, Bill Whelan composer of the world renowned Riverdance. In sport, Sam Lynch of St. Michael's Rowing Club, and another Árd Scoil Rís pupil, is presently the world champion in lightweight sculling. Keith Wood, the World Rugby Player of the Year, like his late father Gordon, has made a legendary contribution to the fortunes of Garryowen FC, Munster, Ireland and the British and Irish Lions touring teams.

Other international political notabilities with strong Limerick roots are Congressman Peter King of the US House of Representatives, whose family hail from Garryowen, and Carol M. Browner, the longest serving administrator in the history of the US Environmental Protection Agency. In President Clinton's Government from 1993-2000, she is a member of the distinguished Browner family of St. Mary's Parish and Thomondgate. Also, the former EU Commissioner Peter Sutherland for whom a tenuous claim can be made because of his education at the famous Benedictine Glenstal Abbey in Murroe.

Mention of Glenstal reminds us that its original owners, the Barringtons, were generous benefactors to the city, through their renowned hospital which served the poor so faithfully for 160 years from 1829 to 1988, and the Mont de Piete which they built in 1836, to take the same poor out of the grasp of the pawnbrokers.

But though both of these institutions are now part of the city's history, the Barrington name will always be associated with the game of rugby, with which Limerick is synonymous. Charles B. Barrington, who was a class-mate of Charles Stewart Parnell at Trinity College, Dublin, was responsible for founding the rugby club there, the second oldest in the world after Blackheath RFC, and also for introducing the code to Limerick. The game has always been extremely popular with all sections of the city's population over the last century, and it has long been established that Thomond Park is the Mecca of the sport in Ireland. The noted rugby commentator, George Hook, has described it as "*the cathedral of sport where the Munster faithful come to worship their heroes*", and wondered "*what the ingredient is, that makes it merit the praise lavished on it by scribes, supporters and players*".

Today that legacy is richer than ever before and greatly treasured by the people of Limerick; it has gained international currency through the epic battles there with the touring teams of New Zealand, Australia, South Africa and the greatest club sides in England, Wales and France. A strongly held belief in Limerick sporting circles, though possibly apocryphal, is that the main reason why Pope John Paul II came to visit Limerick was to see the only place in Ireland where an Irish team – Munster – beat the All Blacks of New Zealand on 31 October 1978.

Limerick Vernacular

One of the fascinating aspects of Limerick's culture for the linguistics expert, or those with an interest in such matters, is the accent, idiom and piquancy of the people's speech patterns and vernacular usage. For Limerick readers especially, it is intriguing to note the enduring similarity of their language to that outlined in his classic work, *English as We Speak It in Ireland*, by their fellow county man Dr. P. W. Joyce of Glenosheen, a leading Gaelic scholar and pioneer in this, and many other aspects of Irish culture. In his preface, he explained that, "*my own memory is a storehouse both of idiom and vocabulary: for the good reason*

that from childhood to early manhood I spoke – like those among whom I lived – the rich dialect of Limerick and Cork".

Almost a century after its publication in 1910, these features are as strong as ever throughout the county and city today. The enduring influence of the Irish language is immediately apparent not merely in the rich deposit of residual Irish words and apt colourful expressions but also in their pronunciation and accent. A very common example is the way the letter R is pronounced in narrow form as in spoken Irish; this is especially the case in the older city communities and public housing estates, where the influences of school elocution classes in English have not yet diluted the invaluable deposit of the centuries old common vernacular. Other examples are what the English people refer to as the Irish brogue, i.e. the insertion of an extra syllable in such words as film, form, and world and the distinctive mode of pronouncing the initial "th" element in such words as Thursday, thinking, through, thick, etc. While this is true of spoken Hiberno-English throughout Ireland, it is still delightfully resonant throughout County Limerick and in the city communities already mentioned. This feature has

been referred to by the county's best known statesman and politician, the former Taoiseach and Uachtarán, Éamonn De Valera of Bruree, when he pointed out that the pronunciation patterns of our English vernacular are Gaelic in origin.

Another distinguished statesman and lawyer, the late John Kelly TD, a former Attorney General, has also commented on the language of the county, especially in the Murroe area of east Limerick, where he thought that the Norman influence was particularly audible in the uvular R sound of the local vernacular. As somebody who was educated in that area in the celebrated Benedictine Abbey at Glenstal and who was acknowledged widely as one of the State's greatest parliamentary orators in the classical Ciceronian tradition, he could be deemed to be well qualified to make such a comment on a topic in which he had a special interest.

Limerick is particularly fortunate also in the huge variety of accents that extend from one end of the county to the other, and which differ from each other, often from townland to townland. This was certainly the case in the city formerly,

where the trained ear can detect different accents in the five ancient parishes of St. Mary's, St. Michael's, St. John's, St. Munchin's and St. Patrick's, embracing such areas as the Abbey, Boherbuoy, Watergate, the Town Wall, Thomondgate, Kileely, Park and Rhebogue.

Old words which survived amongst older people down to the 1950s such as childer (children), flure (floor), dure (door), and goold (gold) have now gone out of use. An interesting facet of this topic was contained in an article in the Observer newspaper in the 1960s, dealing with the population of Tristan da Cunha. They had been evacuated back to London following a volcanic eruption on their island, which was originally an 18th century English colony. The writer commented on the survival rate of archaic words in their speech and their complaints that many of them suffered from the 'teazick' as a result of the notorious London fog. This word for chest related illnesses or colds was commonly used in Limerick up to recently – "s/he has a tizzicky (wheezing) chest".

Other survivals from the Chaucerian dialect of Bargy and Forth in Wexford are, 'scrawb' (scrape)

and 'fong' (a leather boot lace). Still others are the biblical sounding 'ye' (for the plural version of 'you'), 'what ails you?' and 'I would as lief' (as soon) all contribute to the riches of Limerick's colourful vernacular. The older districts where these speech patterns survived for so long have all been demolished under the Limerick Corporation's Housing Programme since the 1930s, and replaced with modern Greenfield housing estates at St. Mary's Park, Killeely, Ballynanty Beg, Moyross, Rathbane, Southill and Ballinacurra Weston, where the strong accent still delights the ready listener.

URBAN RENEWAL PROGRAMME

Limerick Corporation with the customary support of the Shannon Development Company, Waterways Ireland and the Ministry for Arts, Heritage, Gaeltacht and the Islands, were able to incorporate a new marina into the Limerick Main Drainage Scheme, with help from European Regional Development Funds. This state of the art drainage scheme is one of the biggest public enterprise projects ever carried out in the region at a cost of IR£254 million, and is due for completion in 2003.

Other developments under the Urban Renewal Scheme are those at the Docklands and Steamboat Quay, which have transformed these old run down areas into ultra modern residential, commercial centres with hotels, car parks, and a business park at a cost of more than IR£635 million, with the creation of 1,200 jobs. Other historic changes wrought under these programmes were the clearance and refurbishment of the historic St. Francis Abbey area, the King's Island Community Development Plan, the provision of four new hotels with a total capacity of 600 bedrooms and the regeneration of the inner city business centre where incentives induced the changeover of overhead offices to be transformed into residential accommodation over ground floor businesses.

THE LIMERICK CIVIC TRUST

A major contribution to all this unprecedented urban renewal has been the imaginative, artistic restoration of some of the city's oldest buildings and artefacts by the Limerick Civic Trust. The first of its kind in Ireland, it works full-time for the betterment of Limerick and its community through the restoration / preservations of the city's architectural environment and heritage.

Since 1983, under its Director, Denis Leonard, and a dedicated Committee, they have helped to establish 13 of the other 20 civic trusts all over Ireland. In that time also, although self-funding, it has completed more than 90 projects including the refurbishment of the beautiful Georgian House at No. 2 Pery Square as a cultural centre; the city walls at Irishtown, the 17th century Bishop's Palace, which is now its headquarters; the old Potato Market and many other projects which have delighted Limerick people and visitors alike. They also have developed a major folklore archive containing taped conversations on social history.

THE SHANNON DEVELOPMENT PHENOMENON

Central to all this development and indeed to the fortunes of Limerick and Mid West Region generally, has been the contribution of Shannon Development, which can only be described as phenomenal. Founded in 1959, as the Shannon Free Airport Development Company, or SFAD Co, it was the brainchild of one of 20th century Ireland's most gifted and pragmatic visionaries, Ennis born Dr. Brendan O'Regan.

When it became obvious that the invention of the jet engine in the 1950s would make Shannon

International Airport obsolete as a transatlantic refuelling point, it became vitally necessary to devise a scheme which would give it a new lease of life because it had become so important to the economy of counties Clare, Limerick and the Mid West Region generally.

Shannon Development was founded to meet this need, and they were given the responsibility for increasing passenger and freight traffic; to increase job numbers through setting up new industrial enterprises and the enhancement of the tourist industry through the creation of new attractions. How well they carried out this remit is now a matter of legend in industrial and tourism history, throughout Ireland, Europe and many other countries throughout the world, where their name became a by-word for successful innovation.

As Ireland's first dedicated regional development organisation, it became a trendsetter for Ireland in the 1950s and early 1960s, as the country was moving away from the protectionist policy, which had been followed by all Governments since the State was founded in 1922. It established the world's first export Duty Free Zone beside the airport to attract industry there, and the venture was so successful that by 1965, manufactured goods from Shannon were almost one third of the national total. This in turn led to the creation of thousands of new jobs for young men and women throughout Clare and Limerick. Some of them left Newcastle West by bus at 6.30am each day to take up the welcome new opportunities. Limerick city was another beneficiary in this regard, not only for the wages and working conditions, which were a vast improvement on anything they had been accustomed to, but also for all the new skills and training experience. These working conditions had been established by Shannon Development with the leaders of the trade union movement in the Limerick Council of Trade Unions in a far-seeing policy, which set the norms for industries throughout the Region and beyond. Today, over 6,000 people work on the Shannon Free Zone.

Their success in tourism was equally phenomenal with the establishment for example, of Bunratty Castle banquets, which became a model for the industry, all around the world. Other successes in this area were at Knappogue and Dun Guaire Castles, and the refurbishment of King John's Castle by its wholly owned

subsidiary, Shannon Castle Banquets and Heritage Ltd., which is now one of the largest operators of heritage products in Europe. Their portfolio includes Castle Lane, a complete 18th century replica street in Limerick city. Its main benefit to Limerick arguably, was the purchase of the land for the University of Limerick site, which has transformed the city and Mid West region generally. Shannon Development established the National Technological Park on the campus in 1984, as the first Irish Technology Park, on a 650-acre riverside parkland. On this site also, they set up the Innovation Centre to stimulate the growth of new Irish technology companies. Today there are more than 120 companies employing more than 5,000 people.

The industrial, commercial and tourism landscape of the Shannon Region is a reflection of the enduring success of their practical and proven initiatives since their establishment. This vision is being re-cast to meet the changes of the knowledge economy in which Ireland must become a serious player and where the Shannon Region can serve as a laboratory for knowledge-driven economic activity, hopefully with the legendary success with which they have been synonymous.

THE UNIVERSITY OF LIMERICK

The University in turn has become the regional centre for major cultural occasions through its magnificent Concert Hall, which was built in 1993, and is administered by its wholly owned subsidiary company, University Concert Hall Ltd.

Its 1,000 seat Concert Hall, with its magnificent facilities, serves as a cultural centre of the Shannon Region. The Irish Chamber Orchestra and the Daghda Dance Company are based at the University, which has its own student orchestra and choir. Its principal aim is the promotion of operas, concerts and recitals as well as various genres of culture and entertainment for the general public and students. Under the direction of its administrator Michael Murphy, it has been phenomenally successful having attracted many world-class artistes, orchestras, and ballet and opera companies. It has been a boon to the people of Limerick whose traditional love of vocal music is legendary and who had no opera house of their own since the destruction by fire of the Theatre Royal in Henry St. in 1924.

The social development of the city had been seriously hampered by the absence of such a dedicated cultural resource more especially as many schools in the area have orchestras and choirs of their own. The VEC School of Music alone has 1,400 students attending from the region and the city has a number of noted adult choirs as well as local dance and stage schools and a Panto society. The Concert Hall therefore has more than compensated for the absence of a suitable venue, which could host the visit of national and international artists.

THE IRISH WORLD MUSIC CENTRE

Also located in the University Foundation Building with the Concert Hall is another national cultural resource, the Irish World Music Centre under its Director the distinguished composer and arranger Professor Micheál Ó Súilleabháin. It offers an interactive suite of nine MA programmes and related research programmes at Masters and Doctorate levels to students from all over the world.

THE UNIVERSITY ARENA

Still another major national resource centre is located on the eastern end of the University of Limerick campus. The University Arena is Ireland's largest multi purpose indoor sports facility and home to the country's only Olympic sized swimming pool.

It is the largest such sports facility ever built in Ireland, the total cost of which was £20.54m. This athletics coaching and training centre for whole nation is a major asset to the region. The country's first indoor 50m by 25m pool conforms to the competition standards of the International Federation of Aquatics and will undoubtedly have a major incremental beneficial influence on our swimming records. Over a thousand people alone enjoyed the facilities of the pool at its official opening on New Year's Day 2002.

International teams have used the sports facilities at the University during preparation for the Olympic Games e.g. the Australian Junior Olympic Squad. The Munster and Irish rugby teams also regularly use the facilities. The University Arena is arguably the most impressive facility of its kind in Ireland and offers a host of sporting opportunities to its members and the public in the Limerick area.

CITY AND SUBURBS: POPULATION TRENDS

The Limerick Corporation in 1996, made an application to the Minister for the Environment for an extension to the city boundary, which was last delineated in 1950. The present area of the city is 2,086 hectares and the application, if successful, would increase this to a total of 8,537 hectares, 4,830 of which would come from County Limerick and the remainder – 1,621 hectares – from County Clare.

Naturally and predictably, this application has been strongly resisted by the latter two local authorities, impelled by financial considerations, fierce local loyalty and pride of place.

The Limerick Corporation is basing this claim on its belief that the role of the city as the capital of the highly important Mid West Region was being hampered by the fact that the city was too small to meet the needs of the people. The suburbs of the city included in the application, such as Castletroy / Monaleen, Dooradoyle and Caherdavin, are now as big as many county towns, and have developed enormously over the last thirty years or so. The population of the city north of the Shannon is equal to that of Tralee or half that of Dundalk. The reservations of the objectors to the proposal must be answered by the Limerick Corporation and the determination will be made in due course. This process is already in progress.

In matters of population growth, it is interesting to note its various sizes over the last three hundred years or so, as the following table illustrates.

Year	Population
1690	5,000
1831	44,100
1841	48,381
1851	53,448
1861	44,476
1891	37,153
1971	57,160
1981	60,736
1996	52,039

The apparent drop in population by 1996 is rather misleading as over the years there has been a very large drift from the city to the suburbs, the population of which at present is slightly more than 30,000. The number for the city is almost 52,000, which is dangerously near the 50,000 cut

off mark for qualification for European Fund grants for cities of its size.

A corresponding effect of this population shift has meant the decline of some inner city schools and the increasing demand for new schools in the suburbs. By way of example, the primary school rolls of the Sexton St. Christian Brothers School numbered 1,000 in 1950; today their figures are down to 300. By and large the education facilities in the city are comparable with the best in the country generally.

Limerick has a large third level student population. The University has 10,500 students on campus alone, 3,500 students are registered in Limerick Institute of Technology and 2,000 in Mary Immaculate College, which offers undergraduate and postgraduate degrees in Education and the Arts. Third level students contribute to the vitality and cosmopolitan character of the city.

The city and suburbs are particularly well served through its extensive number of second level schools, which range across the spectrum from the conventional secondary schools to vocational schools, community and comprehensive colleges. Most of these are run by the various religious orders which have been involved in education in the city for centuries although increasingly the schools are being run by lay principals and staff. Included in the list are the all-Irish speaking Coláiste at Laurel Hill and Villiers Schools, the latter which has traditionally catered for Church of Ireland and other Protestant denominations.

The city's Vocational Education Committee are responsible for St. Nessan's Community College (700 pupils) a post Leaving Certificate Senior College (500 pupils), the School of Music (1,400), a full time Adult Education college providing a Vocational Training Opportunity Scheme – VTOS – for 200 students. They also run extensive community adult education programmes in 50 different city centres.

There is an equally extensive array of schools in the primary sector. These include the traditional national schools, the religious orders' schools, the Limerick School Project and St. Philomena's private primary school. The Model School, the country's biggest all-Irish speaking primary

school, is based at the Department of Education and Science in O'Connell Avenue.

The all-Irish speaking sector is particularly well catered for by three excellent schools, Gaelscoil Sáirséal, Gaelscoil Seoirse Clancy, and Gaelscoil Caisleán Uí Threoigh. All of these institutions contribute to Limerick's present success story. The quality of our education systems is recognised internationally.

It is true also that our younger people, thanks largely to the vision of a Limerick Minster of Education, Donogh O'Malley, are better educated as a whole than any of their predecessors.

They are reaping the benefits of this at home and abroad. 30% of all American investment was located in Ireland as we faced into the new millennium, even though Ireland only accounts for less than 1% of the EU population. Ireland has the highest percentage of owner-occupied houses in Europe and is amongst the top five countries in the world in this regard.

Despite this material progress however, social problems such as high rates of functional illiteracy / innumeracy and long waiting lists for houses and hospital beds have yet to be tackled successfully. It is hoped that the Social Forum of Government, Business, Trade Union, Farming and other social partners will address these issues as part of their programme.

Limerick, as capital of the Mid West Region whose population is over 317,000, is a modern vibrant cosmopolitan European city. It is nurtured by its pride of place, and aware of its rich historical heritage, which is being increasingly unearthed by archaeologists through the city and county.

It is contributing to and benefiting from the country's new international status and prestige. The fact that one of its citizens, Pat Cox, is President of the European Parliament might reasonably be construed as a symbol of its advance as the 800-year-old city looks to the New Millennium.

Frank Prendergast

Bibliography

North Munster Antiquarian Journal Vol XVII (1975)

Mary Immaculate College / University of Limerick Prospectus 2002/3

Limerick Navigation 1999-2001, Limerick Corporation

Limerick Corporation Development Plan, December 1998

University Concert Hall Limerick 19th – 26th September 1993

Shannon Development: End of Year Review 2001

Amended Proposals for a County Borough Boundary Extension. 1999 Limerick Corporation

Limerick City and the Great Hunger: Limerick Corporation Commemorative Edition 1997

ed. Newman, J., *The Limerick Rural Survey* (Tipperary, 1964)

Bruen Comer, Maire and O hOgain, Daithi, *An Mangaire Sugach* (Dublin, 1996)

Beggan, Gerard, *Patrickswell and Crecora* (, 1990))

Begley, J., *History of the Diocese of Limerick Vols 1-3* (Dublin, 1906, 1927, 1938)

Carbery, Mary, *The Farm by Lough Gur* (London, 1938)

Caroline, Countess of Dunraven *Memorials of Adare Manor* (Oxford, 1865)

Coiste Oideachais Mhuinteoiri Luimnigh, *Limerick - A Handbook of Local History* (Limerick, 1970)

De Lacy-Bellingari, *The Roll of the House of Lacy* (Baltimore, 1928)

Dineen, Len and Keaveney, Mal, *Limerick Sport* (, 2001)

Donnelly, Kevin, Hoctor, Michael and Walsh, Dermot, *A Rising Tide – The Story of Limerick Harbour* (, 1994)

Dowd, J., *Round about the County of Limerick* (Limerick, 1896)

Ferrar, J., *History of Limerick* (, 1787)

Fitzgerald, P. and McGregor, JJ., *History of Limerick Vols I & II* (Dublin, 1826-7)

Hannan, Kevin and O'Donnell, Rev. Father P.J., *Patrick's People* (, 1994)

Hannan, Kevin, *Limerick Historical Reflections* (, 1996)

Hewson, Adrain, *Inspiring Stones - A History of the Church of Ireland Dioceses of Limerick, Ardfert, Aghadoe, Killaloe, Kilfenora, Clonfert, Kilmacduagh and Emly* (Limerick, 1995)

Joyce, Gerry, *Limerick City Street Names* (,1995)

Kearney, Patrick, *William Smith O'Brien – Limerick and Queen's Colleges* in Oideas No 27, Spring 1983,

ed. Lee, David, *Remembering Limerick* (Limerick, 1997)

Lenihan, Maurice, *History of Limerick* (Dublin, 1886)

List Of Mayors And Sheriffs Of Limerick City From 1197 To The Present Day, Limerick

MacMahon, James, *The Pery Square Tontine* (, 1999)

Mac Eoin Gearóid, *The Original Name of the Viking Settlement Limerick*; in Northern Lights; Essays in Honour of Bo Almquist (Dublin, 2001)

Mac Spealain, G., *Cathair Luimnight Vols 1-2* (Dublin, 1948 & 1950)

Mac Spealain, G., *Aos Tri Muighe* (Dublin, 1967)

Mac Lysaght, William, *A History of the Abbey Fishermen* (, Date)

ed O'Callaghan *Adare* (Limerick, 1976)

ed O Cathain, S., *Northern Lights* (Dublin, 2001)

O'Connor, J., *Carrigogunnel Castle* (, 1975)

O'Donovan, J., et al *Ordnance Survey Letters of Limerick* (, 1840)

O Foghludha, R., *Eigse na Maighe* (Dublin, 1952)

O'Flaherty Michael, *The Home of the Spirit – A History of Limerick Rugby*; (,1999)*

O Flynn, Criostoir, *The Maigue Poets* (Dublin, 1995)

O Halloran, A.J., *The Glamour of Limerick* (Dublin, 1928)

O hOgain, Daithi, *An Binsin Luachra - Proinsias de Roiste* (Dublin, 2001)

O Kelly, M.J. and C., *Illustrated Guide to Lough Gur* (Cork, 1978)

O Madagain, B., *An Ghaeilge i Luimneach 1700-1900* (Dublin, 1974)

ed O Maolfabhail, A., *Logainmneacha na hEireann - Contae Luimnigh* (Dublin, 1990)

Potter, M., *Funeral of Wm. Monsell* in Ballybrown Parish Journal, Christmas 2001

Prendergast, Frank, *St. Michael's Parish, Limerick – Its Life and Times* (, 2000)

Scott, A.B. and Martin, F.X., *Geraldus Cambrensis, Expugnatio Hibernica* (Dublin, 1978) cited in

Seoighe, Mainchín, *Portrait of Limerick*: (London, 1982)

Seoighe, Mainchín, *Cois Maighe na gCaor*: (Dublin, 1965)

Seoighe, Mainchín, *County Limerick - Its People and Places* (Askeaton, 1993)

ed Simington, R.C., *The Civil Survey of Limerick 1654-56* (Dublin, 1938)

Spellissy, Sean, *Limerick – The Rich Land,* Limerick 1989

Spellissy, Sean, *The history of Limerick City* (, 1998)

Tierney, M., *Glenstal Abbey* (Glenstal, 1980)

Thomas J., Morrissey S.J., *Towards a National University: An Era of Initiative in Irish Education*: (,1983)

Ua Duinnin, P., *Filidhe na Maighe* (Dublin, 1906)

Woulfe, Rev P., *Sloinnte Gaedheal is Gall* (Dublin, 1923)

Wyse Jackson, Robert, *The Story of Limerick* (Cork, 1973)

Dear Reader

This book is from our much complimented illustrated book series which includes:-

Strangford Shores	Donegal Highlands
Dundalk & North Louth	Drogheda & the Boyne Valley
Armagh	The Mournes
Belfast	Fermanagh
Antrim, Town & Country	Omagh
Inishowen	South Donegal
Heart of Down	Galway
East Belfast	Cookstown
Blanchardstown, Castleknock and the Park	The Ring of Gullion

For the more athletically minded our illustrated walking book series includes:-

Bernard Davey's Mourne Tony McAuley's Glens
Bernard Davey's Mourne Part 2

Also available in our 'Illustrated History & Companion' Range are:-

City of Derry Holywood Ballymoney
Lisburn Banbridge

And from our Music series:-

Colum Sands, Between the Earth and the Sky

We can also supply prints, individually signed by the artist, of the paintings featured in the above titles as well as many other areas of Ireland.

For details on these superb publications and to view samples of the paintings they contain, you can visit our web site at **www.cottage-publications.com** or alternatively you can contact us as follows:-

Telephone: +44 (028) 9188 8033 Fax: +44 (028) 9188 8063

Cottage

Publications

Cottage Publications
an imprint of
Laurel Cottage Ltd
15 Ballyhay Road
Donaghadee, Co. Down
N. Ireland, BT21 0NG